DAVID REED PAINTINGS

MOTION PICTURES

Published on the occasion of the exhibition *David Reed Paintings: Motion Pictures*, organized by Elizabeth Armstrong at the Museum of Contemporary Art, San Diego

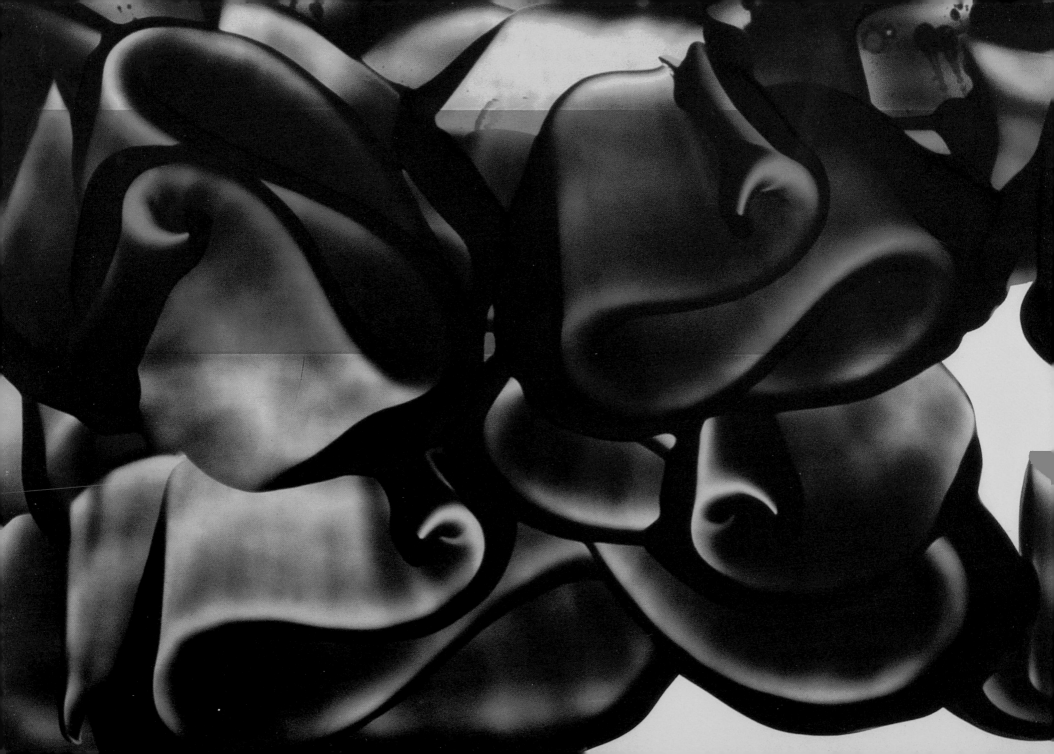

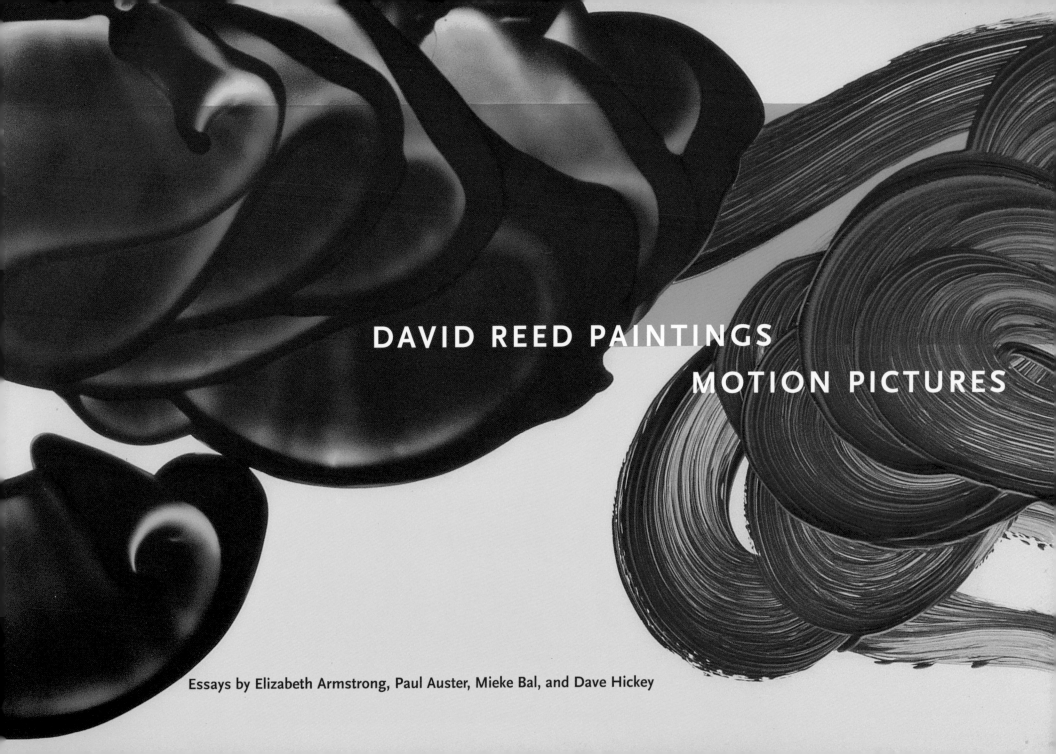

DAVID REED PAINTINGS

MOTION PICTURES

Essays by Elizabeth Armstrong, Paul Auster, Mieke Bal, and Dave Hickey

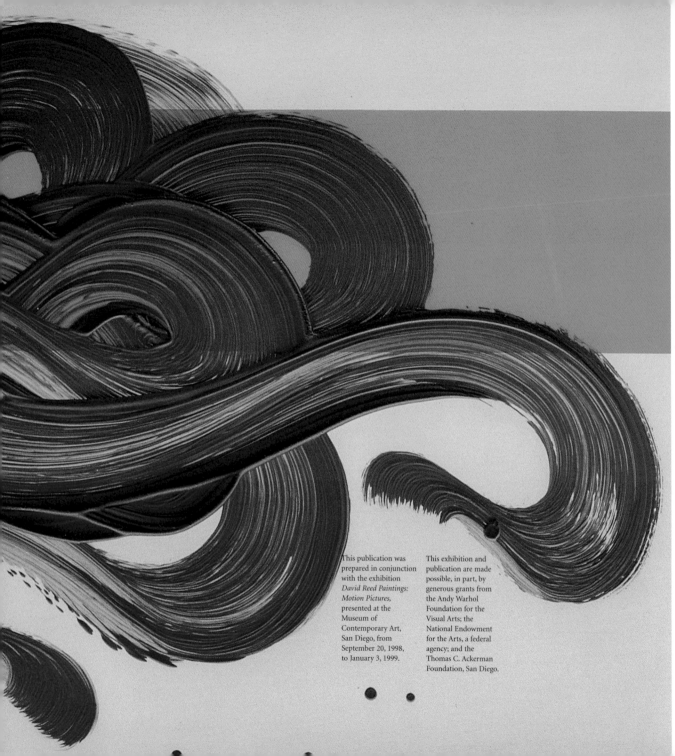

Dedication To my parents, Beverly and David Reed DR 1998

Exhibition Tour

Museum of Contemporary Art, San Diego
La Jolla, California
September 20, 1998–January 3, 1999

Wexner Center for the Arts
The Ohio State University
Columbus, Ohio
January 30–April 18, 1999

P.S. 1 Contemporary Art Center
Long Island City, New York
June 20–end of August, 1999

This publication was prepared in conjunction with the exhibition *David Reed Paintings: Motion Pictures*, presented at the Museum of Contemporary Art, San Diego, from September 20, 1998, to January 3, 1999.

This exhibition and publication are made possible, in part, by generous grants from the Andy Warhol Foundation for the Visual Arts; the National Endowment for the Arts, a federal agency; and the Thomas C. Ackerman Foundation, San Diego.

© 1998 Museum of Contemporary Art, San Diego. All rights reserved. No part of the contents of this book may be published without the written permission of the Museum of Contemporary Art, San Diego 700 Prospect Street La Jolla, California 92037–4291.

Library of Congress catalogue card number 98-066199
ISBN 0-934418-53-5

Available through D.A.P. / Distributed Art Publishers 155 Avenue of the Americas, Second Floor New York, New York 10013–1507 tel (212) 627-1999 fax (212) 627-9484

Designed by Lorraine Ferguson Printed and bound in Singapore.

Cover
(outside and inside):
DAVID REED
#212 (Vice) 1984–85
oil and alkyd on linen
24 x 96 inches
Collection Marjorie
and Charles Van
Dercook, New York

Frontispiece (pages 1–4):
DAVID REED
#345 1992–96
oil and alkyd on linen
26 x 102 inches
Courtesy the artist and
Max Protetch Gallery,
New York

CONTENTS

ACKNOWLEDGMENTS

In 1964, a young art student named David Reed began to take painting classes during the summer at the La Jolla Art Center, now the Museum of Contemporary Art, San Diego. Some thirty years later, this institution is pleased to organize an in-depth survey of this artist's work. The exhibition *David Reed Paintings: Motion Pictures* features forty paintings from throughout the artist's career, along with several of his recent multimedia installations.

This exhibition and catalogue have resulted from the cooperation and assistance of many individuals. First and foremost is David Reed, whose participation has been integral to our project. His knowledge, insight, and, above all, his independent approach to the making and presentation of art has significantly affected our project throughout its evolution. Beyond this, David has been extremely generous with his time and is a complete pleasure to work with. I also wish to thank those working in his studio for the invaluable information and assistance they have provided during the course of our project: Catherine Henry, Tony Shore, Bryan Burk, Andrea Geyer, and Emily Joyce. On behalf of the Museum of Contemporary Art, San Diego, I would especially like to thank the artist's dealers for their contributions. Patricia Faure and Rolf Ricke each offered much assistance, and I would especially like to thank Max Protetch and Josie Browne for their tireless and generous support of this project. The lenders to the exhibition have also been extremely generous, and we thank them for parting with key paintings for the exhibition and its tour. I wish to thank Adrian Korfer for his special generosity in this regard.

I am extremely thankful to the authors of this catalogue, whose texts greatly enrich our understanding of this artist's work: Paul Auster, Mieke Bal, and Dave Hickey. We all share our gratitude to the book's designer, Lorraine Ferguson, whose great expertise and sensitivity to the material are fully evident in these elegant pages. I also thank my many colleagues at the Museum of Contemporary Art, San Diego, without whose support this project would not have been possible. I am especially grateful to Hugh Davies, The David C. Copley Director, whose early enthusiasm gave this project its start in life, and Anne Farrell, Development Director, who helped sustain that life with her superb writing and fundraising skills. A number of staff throughout the Museum have provided indispensable research, editorial, and administrative support. Special thanks goes to Virginia Abblitt, Allison Berkeley-Gullion, Jini Bernstein, Charles Castle, Gwen Gómez, Rita Gonzalez, Dwight Gorden, Andee Hales, Mary Johnson, Toby Kamps, Drei Kiel, Seonaid McArthur, Jessica O'Dwyer, Ame Parsley, and Jennifer Yancey.

I am delighted that other institutions are participating in the tour of this exhibition, and would like to acknowledge and thank Alanna Heiss and

Antoine Guerrero at P.S. 1 Contemporary Art Center, Long Island City, New York, and Sherri Geldin, Donna DeSalvo, and Sarah J. Rogers at the Wexner Center for the Arts, The Ohio State University, Columbus, Ohio.

This exhibition and publication would not have been possible without generous grants from the Andy Warhol Foundation for the Visual Arts; the National Endowment for the Arts, a federal agency; and the Thomas C. Ackerman Foundation, San Diego.

Finally, my heartfelt appreciation goes to my two young daughters, Olivia and Phoebe Boone, who don't yet realize how essential their love has been to me through this project.

Elizabeth Armstrong
Senior Curator

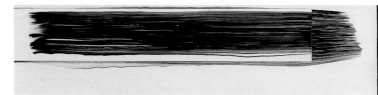

figure 1
DAVID REED
#147 1979
acrylic on canvas
10 x 108 inches
Museum of Contemporary Art, San Diego
Gift of Ruth and Harry Guffee

Hugh M. Davies
The David C. Copley Director

It is a great pleasure for the Museum of Contemporary Art, San Diego to present this exhibition and monograph focused on the career of David Reed. One of the most influential abstract painters of his generation, Reed has long been acclaimed and exhibited in Europe. While he is also well-known to artists throughout the United States, his exposure here has been more limited. We are proud to have this opportunity to organize the first survey of his work in this country.

Reed's abstract paintings have attracted intelligent critique and debate since they first appeared in exhibitions in the early 1970s. Reviewers of his earliest shows quickly noted that his work offered "a new kind of painting" that challenged modernist ideals. Drawing on such art historical sources as Mannerist and Baroque painting, Abstract Expressionism, and Postminimalism, Reed has been equally intrigued by the effects of contemporary photography and CinemaScope film. These diverse interests, and the uniquely complex way in which he filters them in his work, has placed Reed at the forefront of contemporary abstract painting.

In Reed's most recent work, he has further intertwined his interest in photography and film in installations in which his paintings are placed directly next to videos, films, and photographs. Through the juxtaposition of these different media and his paintings' increasingly lush, lurid colors, Reed continues to celebrate painting's sensuality and illusionism while at the same time raising questions of originality, representation, reality, time, and seduction. In his 1995 book,

After the End of Art, Arthur Danto highlighted Reed's inventiveness in situating paintings with other media and honored him as an "examplar of the contemporary moment in the visual arts."

David Reed grew up in San Diego and took art classes at the Museum of Contemporary Art, San Diego (then the La Jolla Art Center), so it is a particular honor for us to host this exhibition. His memories of his childhood in Point Loma and his experience of looking at art here in the Museum have all informed the work. His willingness to share these memories and experiences has greatly contributed to the success of this book. Likewise, Senior Curator Elizabeth Armstrong's commitment to the artist's work, as well as her enthusiasm and tireless care for this project, have resulted in both this unique publication and a dynamic exhibition.

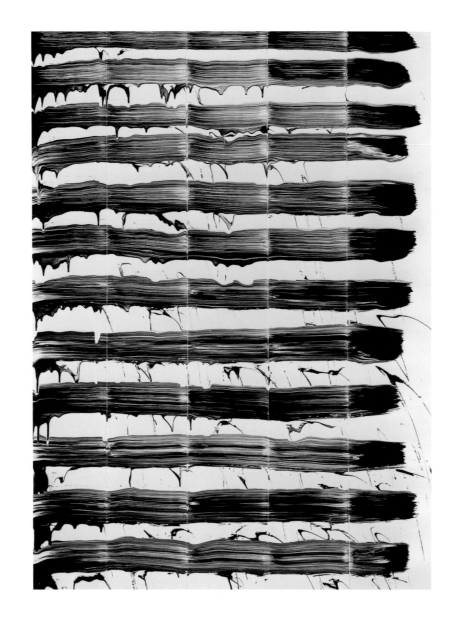

figure 2
DAVID REED
#64 1974
oil on canvas
76 x 56 inches
Sammlung Goetz, Munich

DAVID REED: PAINTING IN THE AGE OF ELECTRONIC MEDIA

Elizabeth Armstrong

"Painting can reflect our current environment.
It has to be radically reinvented to be relevant to the
present. I want my paintings not to be nostalgic
or sentimental—that means they have to be about
this moment."[1]
—David Reed, 1990

The legacy of abstract painting in the United States
still calls up the supreme example of Abstract
Expressionism, with its emphasis on gesture as a force-
ful and meaningful form of expression. David Reed's
art cannot be discussed without this reference—along
with a multiplicity of others, from Baroque painting to
Minimalism. Yet any comparison quickly reveals the
artist's radically different interests and intentions as an
abstract painter, and his unique relationship to his
own time as an artist. At the core of these differences
is Reed's critical interest in technology and the ways
in which contemporary media have altered how we see
and understand our world.

Since the advent of photography, critics have
observed the demise of painting and the resultant crisis
of representation. In his landmark essay "The Work
of Art in the Age of Mechanical Reproduction" (1936),
Walter Benjamin—perhaps seeking to defend painting
from the assault of the machine age (and in particular
photography)— argued that the unique, handmade
artwork had an aura unavailable to the mass-produced
image. Benjamin did not anticipate, however, what a
powerful aura mechanical reproduction could assert
onto works of art. Reed's highly self-aware approach to
painting has been informed by his analysis of the
impact of technological media on his chosen medium.

One of Reed's first mature bodies of work was
a group of canvases known as the Brushstroke paint-
ings. In them, the artist made horizontal strokes in black
or red paint across a surface of wet, white pigment
(figure 2). As Paul Auster explained in his 1975 review
of the work (reprinted in this catalogue): "The hand
moves across the surface in a single, unbroken gesture,
and once this gesture has been completed, it is inviolate.
The finished work is not a representation of this process
—it is the process itself, and it asks to be *read* rather
than simply observed." While referencing the brush-
stroke so essential to Abstract Expressionism, Reed's
gesture is more impersonal, more like the depiction of
the gesture than the gesture itself. It is full of ambiguity
in terms of its desire or ability to convey meaning.
Although these paintings reflect the movement of the
artist's body in making the marks, they were created
by a process more aligned with Minimalism than
Expressionism, grounded as they are on the assertion of
their physical presence and on the literal boundaries of
the canvas.

A number of the Brushstroke paintings were
featured in the artist's first museum show at the
Clocktower in New York City, in 1980. But in the years
immediately following the exhibition, Reed began
to radically rethink how best to express both his

[1] David Reed, "Talking Pictures," *David Reed* (Los Angeles: A.R.T. Press, 1990), p.6.

conceptual and emotional concerns in his painting. He began to work on elongated horizontal canvases, using unexpectedly lush tones and colors. He also began experimenting with surface qualities in the new canvases—sanding them down, using various glazes and transparent layers of paint, and in other ways obscuring the artist's hand in these increasingly polished, voluptuous works (figure 3). As he began to show these pieces, critics compared their swirling, monumental gestures and spatial illusionism with elements of Baroque painting. Indeed, the artist himself, a great admirer of Baroque and Mannerist art, has likened the markings in his work to the billowing cloaks that cover the figures in Baroque painting. "They've either just flown off the viewer's body into the painting or they're about to fly off the painting onto the viewer. The movement is what is important. It reveals the gesture of the body."[2] Critics also commented that the smooth, glossy surfaces of Reed's new paintings, with their artificial Cibachrome or Technicolor hues, looked photographic. Reed was initially surprised by this connection, but he began to realize that this photographic aspect heightened the sense of illusion: it had the effect of giving the painting both distance from "the gesture" and, at the same time, a distinctly powerful presence to the contemporary eye.

Reed has said that a lot of the ideas for these color-enriched, mostly horizontal paintings of the 1980s emerged from visual ideas he had worked out many years earlier while painting landscapes in the desert near Monument Valley. In 1967, while studying painting at the New York Studio School, he had felt compelled to leave the city and paint in the desert. He had a VW in these days, and, since it was very windy in the desert, he installed an easel in the side of the car, nailing it through the body with two-by-fours. ("My father almost died," he told me.) He would then drive out to different locations around Monument Valley, tie a canvas onto his easel/car, and paint:

And I was doing this once and it got very hot midday so I noticed a cave up to the side. I was painting Monument Valley from across the highway. So I went into the cave to rest and eat lunch, and there was a spring in the cave with water coming down over rocks, and I cupped my hands and waited for them to fill up and then bent over to drink and looked out at the entrance to the cave. It suddenly felt very familiar. I was sure I had been there before. I thought that in a previous life I had been an Indian and had been there. I had all kinds of special ideas about my connection to the landscape, that I belonged there, and that I had memories of being there. I remember taking a nap and then walking to the back of the cave into a kind of cul-de-sac that was a beautiful space, that I also seemed to remember.

I bet it was twenty years later that I saw The Searchers *again by John Ford, and the cave is in the movie. The character makes the same gesture I did in drinking from the spring. So that's what connected me to it—I'd seen it in the movies. That's*

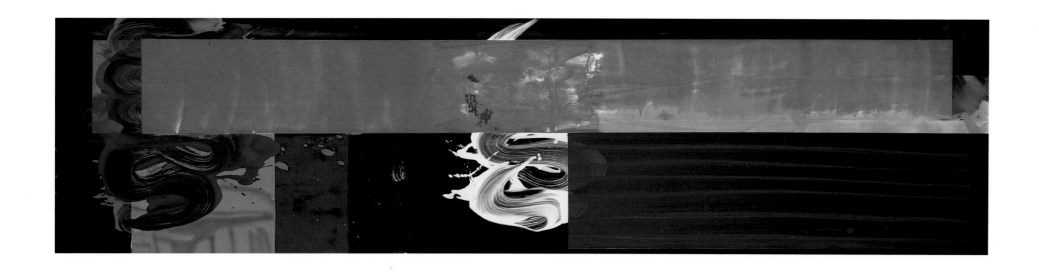

figure 3
DAVID REED
#187–3 (Hollywood) 1982–84
oil and alkyd on linen
24 x 96 inches
Collection Robin and Fred Warren

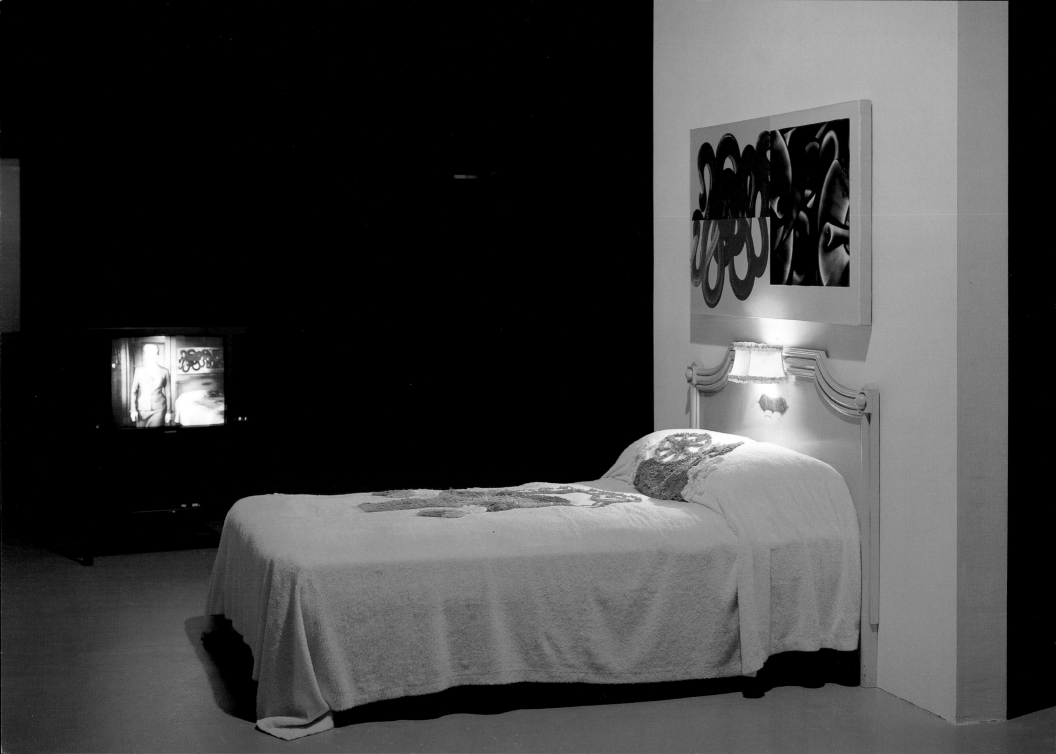

figure 4
DAVID REED
Judy's Bedroom 1992
variable painting featured: *#328*
bed, bedding, bedspread, headboard, lamp,
videotape: **Two Bedrooms in San Francisco, Judy's Bedroom,**
1994, featuring painting *#328,* inserted into Alfred Hitchcock's
film *Vertigo*, Universal Pictures, 1958
dimensions variable
Installation view at Kölnischer Kunstverein, Cologne, Germany

*why it was familiar. This realization had an enormous
effect on my work. I realized how much the way
I saw the landscape was affected by the movies. That
kind of bigness, the unlocated space, the openness,
the freedom, that I connected to Abstract
Expressionism, was also connected to Western movies.*[3]

Reed's revelation that he wasn't a "pure
observer" in the desert—that films had greatly affected
the way he saw the world—would increasingly insinuate
itself into his paintings. Not only were the artificial
colors he used described as Technicolor, but the swirling
forms within them were compared to ribbons of film,
seemingly on the cutting-room floor. The relationship
between film strips and Reed's preference for long
horizontal canvases was noteworthy as well. Expressing
his interest in creating a sense of movement in his
paintings, Reed has commented on the kind of visual
scanning his wide-screen, CinemaScope-like formats
require: "When you look at an isolated part of my long
horizontal paintings, the other parts, which you
see out of the corner of your eye, seem to move, because
peripheral vision is especially sensitive to movement.
. . . I can reinforce this effect with paint—some areas are
blurred like out-of-focus photographs, and others are
rendered sharply."[4] Finally, commenting on the use of
light in his paintings, Reed has pointed out that,
"During the Renaissance and Baroque periods they had
a wonderful religious light that always came from above.
Now we have a technological light, the light of a TV
or movie screen, which is directionless—homogeneous

across the screen—and increases the intensity of every
color. Since we see this light on or through machines,
it seems beyond the human, even immortal."[5]

Unlike most painters of his generation, Reed
has engaged in a significant dialogue with technology.
He traverses the borders of media, incorporating
aspects of computer, video, and film into his paintings,
and vice versa. For example, in his 1995 exhibition at
the Kölnischer Kunstverein in Cologne, Germany, Reed
installed a bed and hung one of his paintings over it.
Next to the bed he placed a television set, on which a
bedroom scene from Alfred Hitchcock's 1958 film
Vertigo played continuously (figure 4). A close viewing
of the *Vertigo* loop, from a movie which Reed has
described as having one of the most perverse love scenes
ever filmed, reveals that the bed in the installation
is a replica of the bed in the film, with the same
headboard and bedspread. But to further complicate the
relationship, Reed has inserted—through the use of
digital technology—one of his own paintings (*#328*,
1990–93) into this same scene in the film, in just the
spot we find it hanging over the bed in the installation.

Reed's meditations on painting and film took
another turn as he worked on an installation for the
spectacular "Mirror Room" at the Neue Galerie of the
Landesmuseum Joanneum in Graz, Austria, in 1996
(figure 5). This gilded hall of mirrors and lights is
located in the region where some of the most famous
vampires are said to have stalked their prey. In
preparation for the exhibition, Reed watched over

3 The artist in conversation with the author, 29 December 1997.

4 Reed, op. cit., p. 15.

5 Ibid., p. 4.

eighty vampire movies. He had a distinct childhood memory of seeing a film in which the vampire's identity was discovered because he was not reflected in a mirror. After watching a number of films that, disappointingly, made no reference to "non-reflection," he finally came across Tod Browning's classic 1931 *Dracula,* with Bela Lugosi playing the Count. In one scene, a mirror in the top of a cigarette case betrays the fact that the Count has no reflection, proving that he is a vampire. Further research by the painter uncovered the original reference to non-reflection in Bram Stoker's 1897 *Dracula.* Reed points out that this novel is also filled with references to the new technology of its time— typewriters, cameras, dictation machines, blood transfusions, train schedules—and that the first public film screenings in England were held in 1896, a year before Stoker's novel was published. Reed has theorized that Stoker saw the vampire as the symbol of a new kind of technological perception: his stare was cold, dead, without awareness, like the eye of a movie camera, and he mesmerized his victims much as a film does its audience. In the catalogue for Graz, Reed commented that "vampire stories describe the fear and anxiety caused by the technological extensions of our bodies. We are part human and part machine, part living and part dead, and we don't know how to deal with this knowledge. Warhol wanted to be a machine; now we all know that we are part machine. We use eyeglasses, hearing aids, computers, and other machines to extend our bodies. And we have internalized the perceptions of technological machines: photography, film, and video. We dream in pans, close-ups, and moving camera shots."[6]

Later that same year, Reed was featured in an exhibition at the University of Nevada, Las Vegas. Here he installed nearly one hundred computer-generated stills captured from films and television programs set in Las Vegas. Attached to the gallery walls on an exposed grid of Velcro, they were interspersed among thirty-eight of Reed's contemporaneous small paintings. The affinity between the color and composition of the stills and Reed's small paintings reflected the artist's sources—from the panning movement of a TV camera to the unnatural palette of Las Vegas casino culture. Not surprisingly, one of the side effects of this bravado installation was to illuminate several of the artist's large canvases, hung in an adjacent gallery. The flat, patterned grid of the walls of color photocopies lent a particularly visceral aura to the large illusionistic paintings, which in the words of one reviewer were "so alluring that they not only tease the eye, they actively lure the guilty hand into illicit caresses."[7]

I have suggested here a few of the ways in which Reed, through his interest in technology, has kept his painting connected to his own time. Nonetheless, it must have been a challenge, especially during the 1970s and '80s, to maintain loyalty to a medium considered by many to have died earlier in the century. I asked him how he dealt with continual pressure by his peers to consider another artistic route. Reed proceeded to tell

6 David Reed, "Journal," *New Paintings for the Mirror Room and Archive in a Studio off the Courtyard by David Reed,* exh. cat. (Graz, Austria: Neue Galerie am Landesmuseum Joanneum, 1996), p. 18.

7 Carmine Iannaccone, "David Reed at Patricia Faure," *LA Weekly* (March 14–20, 1997), p. 64.

me about his encounter with Marcel Duchamp in 1963:

> *I had gone up to the Pasadena Museum to see the*
> *Duchamp retrospective when I was in high school,*
> *and Duchamp was in the galleries. I kind of followed*
> *him around and looked at the show over his*
> *shoulder because I knew that you could see works*
> *better when someone else was looking at them,*
> *you know, and learn from the way they were seeing.*
> *And it became kind of embarrassing because we*
> *were the only two people there and I was kind*
> *of tagging around after him. So he was very kind*
> *and turned and talked to me, you know, and*
> *asked me where I lived and what I was doing, and*
> *what I remember most is that he said, "I regret giving*
> *up painting. I shouldn't have given up painting."*[8]

It would seem almost predestined that this younger, conceptually based painter would receive the blessings of the artist whom we most associate with the rejection of twentieth-century painting; it certainly helped to fuel Reed's own belief in his pursuit of this medium. Duchamp's entire body of work, from his *Nude Descending a Staircase,* 1912, and his first readymade, *Bicycle Wheel,* 1913, to *The Large Glass,* 1915–23, reflects his profound awareness of the impact of the machine age on art. When people said to Reed that he should give up painting—and especially when they would argue for work like Duchamp's—he could smile politely and hear them out. After all, he had insider information.

[8] The artist in conversation with the author, 29 December 1997.

figure 5
DAVID REED
Mirror Room for Vampires 1996
variable paintings featured: *#349, 350*
mixed media, videotape: compilation of scenes
from vampire movies involving mirrors
dimensions variable
Installation view at the Neue Galerie am Landesmuseum
Joanneum, Graz, Austria

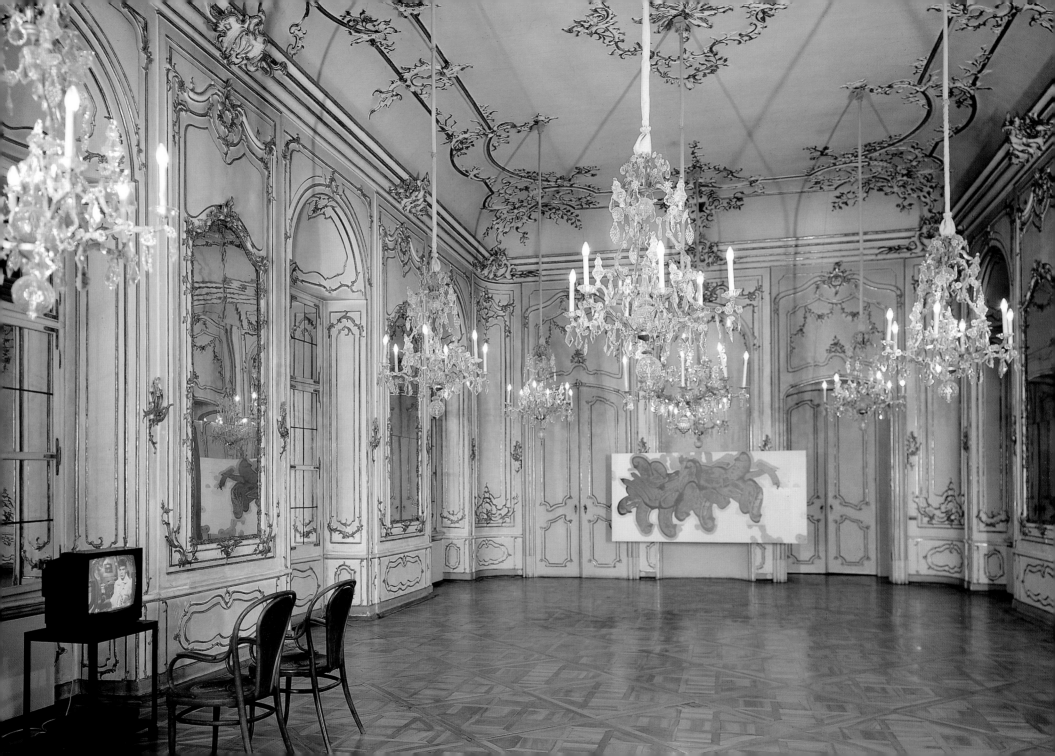

BLACK ON WHITE: PAINTINGS BY DAVID REED

Paul Auster

The hand of the painter has rarely instructed us in the ways of the hand. When we look at a painting, we see an accumulation of gestures, the layering and shaping of materials, the longing of the inanimate to take on life. But we do not see the hand itself. Like the God of the deists, it seems to have withdrawn from its own creation, or vanished into the density of the world it has made. It does not matter whether the painting is figurative or abstract: we confront the work as an object, and, as such, the surface remains independent of the will behind it.

In David Reed's new paintings, this has been reversed. Suddenly, the hand has been made visible to us, and in each horizontal stroke applied to the canvas, we are able to see that hand with such precision that it actually seems to be *moving*. Faithful only to itself, to the demands of the movement it brings forth, the hand is no longer a means to an end, but the substance of the object it creates. For each stroke we are given here is unique: there is no backtracking, no modeling, no pause. The hand moves across the surface in a single, unbroken gesture, and once this gesture had been completed, is it inviolate. The finished work is not a representation of the process—it is the process itself, and it asks to be *read* rather than simply observed. Composed of a series of rung-like strokes that descend the length of the canvas, each of these paintings resembles a vast poem without words. Our eyes follow its movement in the same way we follow a poem down a page, and just as the line in a poem is a unit of

breath, so the line in the painting is a unit of gesture. The language of these works is the language of the body.

Some people will probably try to see them as examples of minimal art. But that would be a mistake. Minimal art is an art of control, aiming at the rigorous ordering of visual information, while Reed's paintings are conceived in a way that sabotages the ideas of a preordained result. It is this high degree of spontaneity within a consciously limited framework that produces such a harmonious coupling of intellectual and physical energies in his work. No two paintings are or can be exactly alike, even though each painting begins at the same point, with the same fundamental premises. For no matter how regular or controlled the gesture may be, its field of action is unstable, and in the end it is chance that governs the result. Because the white background is still wet when the horizontal strokes are applied, the painting can never be fully calculated in advance, and the image is always at the mercy of gravity. In some sense, then, each painting is born from a conflict between opposing forces. The horizontal stroke tries to impose an order upon the chaos of the background, and is deformed by it as the white paint settles. It would surely be stretching matters to interpret this as a parable of man against nature. And yet, because these paintings evolve in time, and because our reading of them necessarily leads us back through their whole history, we are able to re-enact this conflict whenever we come into their presence. What remains is the drama: and we begin to

figure 6
Installation view of the artist and painting #90 at the Susan Caldwell Gallery in New York, 1975.

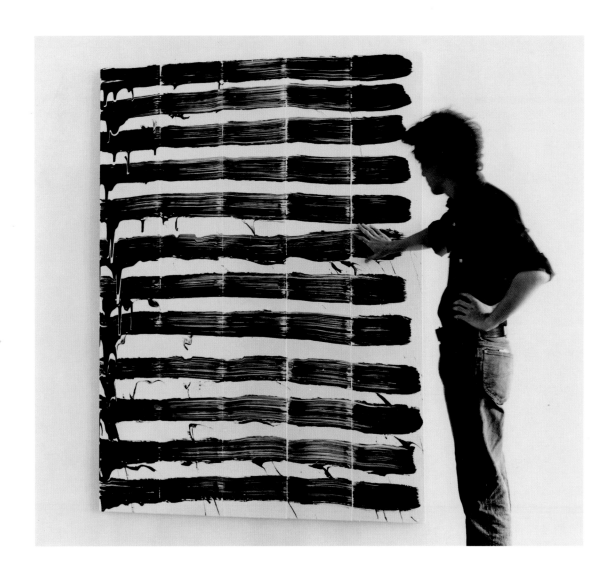

understand that, fundamentally, these works are the statement of that drama.

In the last sentence of Maurice Blanchot's novel, *Death Sentence*, the nameless narrator writes: "And even more, let him try to imagine the hand that has written these pages: and if he is able to see it, then perhaps reading will become a serious task for him." David Reed's new work is an expression of this same desire in the realm of painting. By allowing us to imagine his hand, by allowing us to see his hand, he has exposed us to the serious task of seeing: how we see and what we see, and how what we see in a painting is different from what we see anywhere else. It has taken considerable courage to do this. For it pushes the artist out from the shadows, leaving him with nowhere to stand but in the painting itself. And in order for us to look at one of these works, we have no choice but to go in there with him.

This essay was written in 1975 and is reprinted here with permission from the author. It was first published in *The Art of Hunger*, 1992.

DAVID REED'S COMING ATTRACTIONS

Dave Hickey

You'd think the moral universe of painting would be simpler, that it wouldn't have all the complications you have in life. In fact, it's filled with all the ambiguities and moral complications one experiences in life. It isn't different. It isn't separate.
—David Reed, 1990

THE BODY IN THE BOX

It began with a problem at work. In the mid-1960s, not long after David Reed began making abstract paintings, he realized that he didn't know where he was when he was painting. He seemed to be in so many places at once. Whenever he was working, he would be inside the painting and working in the world. Everything he did in that place was determined by the touch and tempo of his body as he worked. But he would be outside the painting, as well, and inside his head, working on another painting that was the same painting except it floated before him without size or weight, like a rectangular balloon. The work he did inside the painting (in the outside world) could change the picture in his head, of course, and vice versa, but they were never the same and never in sync. His body moved more quickly and knew more, could see more and in more detail, so there was always this *drag* because he was in so many places at once. He did not like the feeling that he might not put himself back together again.

Other painters, not liking this feeling, had made choices that Reed found unappealing. Jackson Pollock had chosen to move inside the painting and labor in the physical world. Barnett Newman had chosen to move out of it, to work in weightless sublimity. Edward Ruscha had made a lovely joke out of his inability to choose. For a painting called *Actual Size* (figure 7), Ruscha had divided a large canvas into an

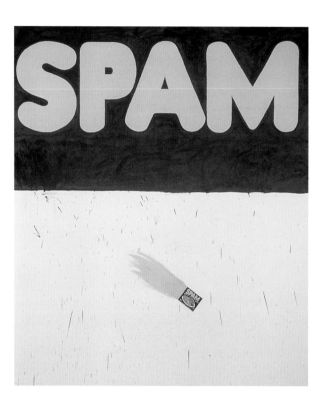

figure 7
EDWARD RUSCHA
Actual Size 1962
oil on canvas
72 x 67 inches
Los Angeles County Museum of Art

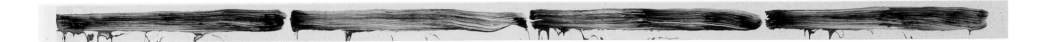

figure 8
DAVID REED
#95 1975
oil on canvas
8 x 214 inches
Collection Chase Manhattan Bank, New York

upper and lower rectangle. Across the top of the upper rectangle, he painted the word "SPAM" in large logo letters. In the lower rectangle, he glued an actual label from a can of Spam, at a descending angle, then painted "speed lines" above it, so the image seemed to be plummeting through space like a falling star. The upper realm, then, presented itself as some kind of ironic "heaven," the timeless, weightless, sizeless domain of concept and language. The lower realm was "earth," a place where objects have size and weight and live in time.

It was a subject-object problem, of course, and Ruscha's painting solved it by demonstrating that it couldn't be solved—that the dance of subject and object was infinitely recursive. The best an artist could expect was the chance to play the music for a while, and David Reed understood this. He also shared Ruscha's affection for the abject realm of plummeting Spam cans. Mostly, though, he envied the nonchalance with which Ruscha worked in four places at once—so much so that, around 1975, Reed set about trying to make himself more comfortable in the theater of painting by shortening his visits—by getting in and getting out. He began making "fast" paintings composed of quick, individual, horizontal brushstrokes. His favorite was #95 (figure 8). Eight inches high and two hundred and fourteen inches long, the painting was composed of four, quick horizontal brushstrokes, as long as his body could make them, laid end to end. A friend named it "The Baseball Painting" because it amounted to running the bases.

"The Baseball Painting" is David Reed's *Actual Size*. It locates the painter's maximum, "actual size" brushstrokes within the territory of a rectangle that can be any size it wants to be—that might be extended infinitely. The painting's narrative—that of an actual-size painter marking his reach in brushstrokes along the surface of a theoretically infinite rectangle—reverses the trope of Roy Lichtenstein's "Big Brushstrokes" whose gargantuan, benday gestures invite us to imagine this gargantuan, cartoon de Kooning standing before his gargantuan canvas, arms folded, thoughtfully admiring his work (figure 9). More than this, however, "The Baseball Painting" (which could hardly be simpler) demonstrates for us the ground-level condition of painting—its bedrock narrative—by dramatizing the incommensurability of the mind's cultural language of tidy rectangles and the body's untidy, curvilinear progress through a world populated by just such objects.

In the same year, 1975, Reed's friend and fellow San Diegan, John Baldessari, made the same point similarly in a series of four photographs called *Strobe Series/Futurist: Trying To Get a Straight Line with a Finger* (figure 10). In each of these photographs Baldessari tries to make a straight line in the air by moving his finger in front of the camera's aperture under a strobe light. He fails to do so, ignominiously, every time. As reproduced in the photographs, Baldessari's wobbly moving finger creates a horizon-line that is every bit as irregular and contingent as Reed's

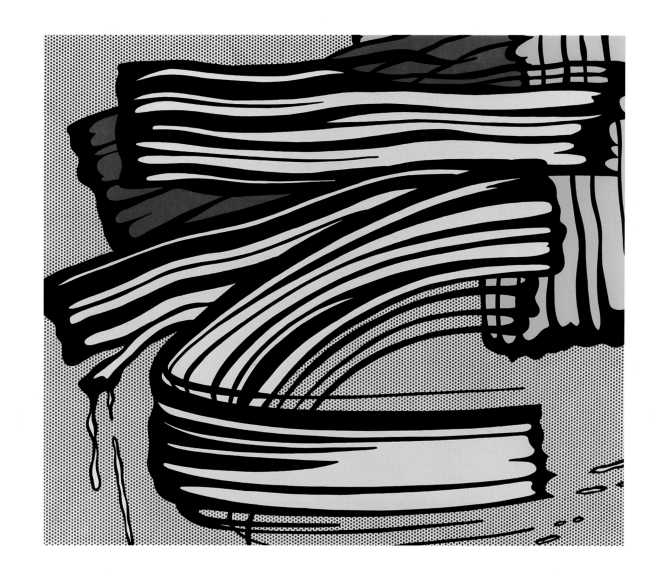

figure 9
ROY LICHTENSTEIN
Little Big Painting 1965
oil and synthetic polymer paint on canvas
68 x 80 inches
Collection Whitney Museum of American Art, New York
Purchase, with funds from the Friends of the
Whitney Museum of American Art, 66.2
© Estate of Roy Lichtenstein, 1998

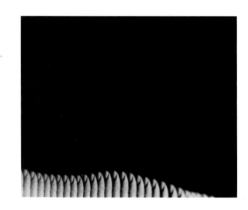 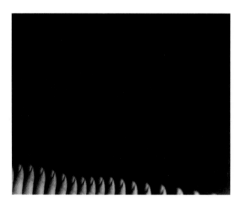

figure 10
JOHN BALDESSARI
Strobe Series / Futurist: Trying To Get a Straight Line with a Finger 1975
four black-and-white photographs; mounted on board
16 x 20 inches each
Courtesy Sonnabend Gallery, New York

painterly gesture, and just as incommensurate within the crisp, conceptual rectangle of the photograph. In one way or another, then, all of these works (Reed's, Ruscha's, Lichtenstein's, and Baldessari's) tell one side of the same story—the story of "the body in the box" as told by the "gesture in the frame"—or, more precisely, by the figure in the rectangle.

This is the great story of late twentieth-century art, of course, and as such, it has been variously construed—as the story of earthly heroes striving to cast off the shackles of their received ideas—or the story of deluded animals willfully resisting the formal imperatives of God's plan, Nature's cycles, pure Concept, or History's implacable logic. Most recently, the story of "the body in the box" has been proposed as the social narrative of a specific historical moment during which human beings begin to outgrow the necessary regimentation of industrial culture and move outward into a more fluid and complex post-industrial world. However construed, David Reed and his co-religionists make the case for the defense. They tell the story of "the body in the box" from the body's perspective, at a moment in the history of American art when the arctic boxes in which works of art are most prestigiously exhibited, constitute the absolute, hardwired, apotheosis of that colorless, weightless, timeless domain (outside the painting and inside the mind) where the body's work dissolves into ghostly discourses of status and virtue.

David Reed learned this lesson from his early exhibition career: that the abstract language of the white box, which is "purely" abstract, always co-opts the abstract language of its contents. Thus, in the late 1970s, Reed would abandon his "fast and rough" brushstrokes, because "fast and rough," in the language of the white box, was presumed to signify a contempt for painterly practice. In response to this and not wishing to be misunderstood, Reed's gestures became large and gorgeous, translucent and transgressive. Like willful, Baroque angels, they ceased to respect the rectangle or the picture plane. Spilling out over the rectangle's hard boundaries and blossoming up within its frame, Reed's new gesture made space where none existed, then flowed away into that space beneath the rectangle's enclosing edges, as Jim Rosenquist's figures do, inferring a vast, complex, and multi-tiered figural landscape of which the tight aperture of the rectangle affords us only a glimpse (figure 11).

At this point, the body was symbolically out of the box, but the box still prevailed. Reed's paintings were still abstract and vulnerable to the box's ideal of abstraction, which, presuming the body's abjection and the mind's dominion, presumed transgressions on beauty's behalf to be cosmetic and decorative, inauthentic and incorrect. This vulnerability, Reed decided, was both the strength and weakness of abstract painting. It was totally *positive*. It could not repudiate its context; but rather sought its context and redeemed that. So symbolic transgression was not enough. The box *ate* symbols. Celebrating the actual-size, real-time world of the body's dominion in a museum painting was not

figure 11
JAMES ROSENQUIST
Vestigial Appendage 1962
oil on canvas
72 x 93 1/2 inches
The Museum of Contemporary Art, Los Angeles
The Panza Collection

28

enough, because that actual-size world was not a subject, it was a place. Art could go there, had been there in the past and might go again. For this to happen, however, the body must literally depart the box. An artist must passionately and publicly commit not to just the content, but the work itself to that quotidian destination. The moral universe of painting isn't different. It isn't separate.

THE BED IN THE BOX

By the early eighties, then, David Reed knew exactly what he didn't want to do. He didn't want to decorate galleries and museums with "objects" that made "statements." He also knew exactly what he wanted to do, but he didn't know what to call it except work. He wanted to make abstract paintings, every day, as a part of his normal life, and he wanted these paintings to be an integral part of other people's normal lives. This required a new idea of abstract painting. As a starting point, he liked Gerhard Richter's proposal that an abstract painting was simply another kind of "picture," like a landscape or a still life, as vulnerable and responsive to our desires and expectations as any other picture in the social world—that could be read in the same way that we read a landscape or a still life, as an allegory of relationships.

Reed had been taught, of course, that an abstract painting was a non-representational object in the world through which one might acquire some un-representable object in the mind, but this had always been unappealing to him because he was not really interested in objects, in the mind or in the world. He was concerned with what he called the "verb effect" —with abstract painting as a kind of transitive, domestic oratory that was the farthest thing from non-representational—that could, in fact, represent any-thing, could snare vast discourses in its constellations of reference and be read, not as one reads a book, but as one reads the weather or the body language of a friend. This was possible, he felt, because abstract painting, most critically and more clearly than any other kind of painting, represented the beholder in an active and intimate social relationship.

So David Reed wanted to make paintings that happened and continued to happen in moments of private reverie for the people who lived with them over the years. To do this, he felt that his paintings had to be *full,* over-full even—that they should try to engage all the things he loved within their constellations of reference—should activate the full content of his reverie. So, first and foremost, the oratorical magnifi-cence of Baroque painting had to be there—that shimmering drama of flesh and fabric, the dance of clear gesture and real emotion in the stark theater of Neapolitan light—which was California light, as well—and California had to be there, too, the California of his childhood, the jumble of houses and palms climbing the hill above the beach, the swirl of pink stucco and the

gleam of lowriders, the sweet emptiness of cool, bright rooms and the sinister glamour of summer sunsets. So, too, did the Great American Desert have to be there, somehow, like a vast, loveless ocean in hard light, in all its crumpled, inchoate, soul-stealing actuality, but also in the luminous translucent theater of John Ford's films where the earth and clouds and sky flow like water across the screen, trembling and shifting in that long Vista-vision rectangle, like flesh and fabric in a Baroque painting.

All these things would have to be there, then, and when he finished his new paintings and saw that they all were, in fact, there, he understood that, for all these things to be positively there, the paintings had to be abstract—but not abstractions from what he had seen. They had to be concentrations of what he brought home in physical memory—distillations of desire— the best things you ever brought home in your body. He was thinking about this, about the things you brought home in your body, one afternoon in New York in the late 1980s, while he chatted with his friend Nick Wilder about a painting by John McLaughlin that reminded him of home. In the midst of their conversation, Wilder, who was a painter himself, and a dealer as well, observed that McLaughlin was a "bedroom painter," maybe the first abstract "bedroom painter."

When David Reed asked him what he meant, Wilder explained that people routinely bought McLaughlin's paintings from him with the intention of hanging them in their living rooms. Then, almost invariably, these people would move their McLaughlin's to the bedroom so they might live with the paintings on more intimate terms. "That's my ambition in life," David Reed said suddenly, "to be a bedroom painter." Now, suddenly, he saw the destination his paintings sought. He had a name for it. He would distill the best things he ever brought home in his body into paintings that, hopefully, would be the best things that other people ever brought home in a truck. These paintings would hang in people's bedrooms—in those private spaces where lives and days begin and end—those havens of our nakedness where we abandon ourselves to sleep and sex and the private reverie of books and images. This was the true armature of his endeavor.

Unfortunately, having come upon this truth, Reed still had to face the facts, and the fact remained that the white box of the gallery and the white box of the museum still stood like guardians at either end of his paintings' transit through the domestic world. They still had to be accommodated, and now that he knew what he was doing with his painting and where it was going, he couldn't overcome his feeling that his paintings looked naked in the white box—in a place where nakedness was far from a virtue. He wanted the public to see his paintings, of course, but he wanted them to be seen where they lived or aspired to live, to communicate some idea of where they belonged. As an interim measure, then, he began digitally inserting his paintings into films and that seemed to work. He hung his paintings in the bedrooms in Hitchcock's *Vertigo,* and

exhibited the video, and, somehow, a picture of one of his paintings in a fictional bedroom seemed more authentic to him than an actual painting of his in a fictional box.

Then, in 1992, for an exhibition in San Francisco, Reed moved a bed into the gallery where his paintings were hanging, and that worked too. Unfortunately, when he told his friends in New York what he had done, they said, "Oh wow, now you're an 'installation artist.'" Reed was appalled; he insisted that he was in fact an "anti-installation" artist. Installations, Reed insisted, were fictional aggregations of readymade objects arranged in a white box by an artist who wished to comment upon, interrogate, or otherwise critique the content of life outside the box. For installation artists, the white box is *real,* and the world beyond it a miasma of false consciousness and cultural schizophrenia. The paintings David Reed hung on the wall in San Francisco, however, were not fictional paintings. They were actual-size, primary objects, and the bed in the center of the room was not there to comment upon the private lives of fictional occupants. It was there to insist on the paintings' status as actual-size objects in the world, to mitigate the fiction of the white box and remind us that the bedrooms in which these paintings ordinarily hang were not fictional bedrooms—that they were, in fact, actual rooms inhabited by actual citizens of the republic whose names are listed on the card on the wall.

So when Reed moves a bed into a gallery, as he is still wont to do, we are not dealing with academic "contextualization." The power of the official white box is not being enlisted here to fictionalize the objects it contains. Rather, Reed is engaging in an act of Pop transgression. He is using the bed to compensate for the positivity of abstract painting, which, since it is unable to repudiate its context, must bring its context with it. An image that portrays some object beyond the context does not have this problem; it has enough negative power to defend itself if necessary. Thus it was clear to everyone (with notable exceptions) that Andy Warhol's *Marilyn,* hanging in the Whitney Museum, constituted a critique of the museum, not Marilyn Monroe. Everyone recognized that the painting was displacing value from its immediate context and insisting on the primacy of quotidian culture. David Reed's helplessly generous and irrevocably positive paintings require an attendant Beauty Rest to perform this act of self-defense. Together, however, they conspire to critique their context, to theatricalize the authoritarian, Platonic fiction of the white box, and insist upon the primacy and majesty of private experience—of the heroic *intime.*

OTHER BEDROOMS NOT OUR OWN

The white box came first—the Acropolis being the first white box. The tradition of Western art begins there and continues in the forums and churches of Mediterranean civilization, grounded in the visual culture of church

and state and informed by its iconography of sacred and civic virtue. No one would deny this. One must suggest, however, that Western art only becomes art as we know it in the paintings designed to adorn aristocratic bedrooms of fifteenth- and sixteenth-century Italy. It was during this period that the bedroom itself was reinvented as a domestic refuge and an accouterment of privilege, and from that moment onward, for nearly three centuries, a vigorous market flourished in "bedroom paintings" specifically designed for those new redoubts. Principally, but not exclusively, these were paintings of erotic nudes of both sexes, alone or together, in salacious poses.

Most of these bedroom paintings are lost to us now, having been destroyed, suppressed, or made modest by over-painting in the name of virtue. Even today, in fact, rumors persist that the bulk of these "problematic" pictures reside in the basements of the Vatican. If they do, this is probably as it should be, since the corporeal glory of sacred art during the Renaissance derives its power and identity from the appropriated erotics of these bedroom paintings—from their fields of naked flesh, fine fabric, and precious stone—from the glamourous appeal of their unstable and destabilizing invitation to *respond*. Today, theoretically, we may re-experience the intimate invitation of these bedroom paintings as we stand before Titian's *Venus d'Urbino* (figure 12) or Caravaggio's *Bacchus* in the Uffizi's galleries. In truth, that original, instantaneous bang is only arduously accessible, muffled by the aura of public sanctity and the reams of learned commentary we have internalized.

It is possible, however, to stand there before Titian's *Venus* long enough to stop looking at it and begin to see it, to sense the hard, visible object in the atmosphere of the physical space and sense the visceral impact such a painting must have had, hanging in a shadowy, private room whose open windows look out upon the sun-blanched fields and blank walls of an image-poor Italy. One is assisted in this de-sanctification by remembering that when Guidobaldo de Montefeltro, Duke of Urbino, was negotiating to buy his *Venus* from Titian in 1538 (and trying to borrow money from his mother to pay for it), he referred to this icon of Western civilization simply as a painting of "a naked woman"—and by remembering, as well, that, when Cardinal Farnese saw Guidobaldo's "naked woman" at the Duke's summer residence in 1542, he immediately set off to visit Titian in Venice and commission a similarly erotic nude of his own. Some time later, reporting back to the Cardinal on the progress of his painting, the Papal Nuncio would assure Farnese that his nude-in-progress made Guidobaldo's Venus look like "a frigid nun."

These facts are well known, of course, and oft cited as evidence of the under-evolved consciousness of Renaissance princes. They take on new interest, however, when a contemporary painter like David Reed consciously re-activates this tradition by announcing his ambition to be a "bedroom painter." Admittedly, it is the

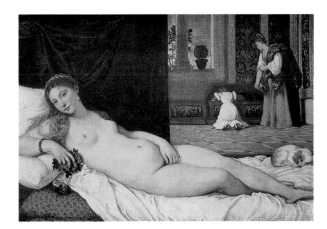

figure 12
TITIAN
Venus d'Urbino 1538
oil on canvas
46.75 x 65 inches
Uffizi Gallery, Florence, Italy

announcement as much as the paintings themselves that creates the interest. There are a great many bedroom painters and there always have been, but there are not many abstract painters like David Reed with the stature and authority to make a public issue of the practice. Also, since Reed's paintings themselves must bear this new meaning, it is important to consider the extent to which he has translated the erotic vocabulary of Titian's painting (which is the erotic vocabulary of bedrooms themselves) into the language of post-conceptual art.

When we look at Titian's *Venus* in the context of Reed's painting, we immediately recognize the same vocabulary in a quieter, earlier form. Titian's painting is more sedate and chromatically pedestrian than Reed's, but this is less attributable to Reed's twentieth-century eye than to the fact that Reed's true mentors in the practice of bedroom painting post-date Titian by a generation or so. In any case, Reed's basic vocabulary is totally present in Titian's painting. The long, curvilinear swath of the naked Venus on her couch sweeps across the rectangle of a canvas that is subdivided into a field of colored rectangles. In Ellsworth Kelly's phrase, these rectangles are "less composed than arranged." Moreover, the body of the naked Venus is barely enclosed by the edge of the canvas. The ends of her bedclothes spill off on either side of it, and this has the effect of forcing the body of Venus forward, of pitching it into the room where the woman's gaze is fixed and where we stand, thus disassociating Venus' corporeal presence from the geometric, pictorial space behind her.

This pictorial space is also disassociated from itself—oddly and uncomfortably divided in half, with Venus' pudenda precisely front and center. The left half of the background depicts the black opacity of Venus' bed-curtain in the near-middle-distance; the right half falls away into the bedroom itself where Venus' two servants are preparing her toilette. The whole picture, then, is a very anxious and unstable arrangement of forms and spaces, and, standing before it in the Uffizi, we are somehow disturbed by its seeming clumsiness. At the same time, we recognize that part of our distress derives from the fact that these formal deficiencies, these apparent infelicities, constitute the very engine of the painting's erotic appeal. It is the odd disassociation of Venus' body from the domestic interior behind her, and the clumsy presentation of her pudenda on the centerline, that lets her out of the box—that makes her seemingly available to us. This causes anxiety and instability. Anxiety and instability cause excitement, but excitement, we must remember, does not *necessarily* cause pain.

As disturbing as these tensions might be in the Uffizi, one can easily imagine how pleasantly exciting they must have been in the Duke's bedroom, amidst the chaos of its inviting surfaces. Anxiety is always a matter of degree and a creature of its context, and, thus, in a painting, anxious dissonance does not necessarily signal aggression, avant-gardism, or ineptitude. The dissonance of warm corporeality and cool geometry that both Titian's and David Reed's paintings exploit

(and to which so much social distress can be attributed) can, in the right circumstances, in the right hands, be sexy as hell. Thus, if we locate the source of Reed's energy where we locate Titian's—in the bedroom—in the anxious combination of ravishing surfaces—the alterations of style and manner that Reed's paintings have undergone since the mid-seventies make profound erotic sense. All of these changes and refinements have had the effect of intensifying the surface appeal of the paintings while exacerbating the dissonance of their parts.

He has cranked them up and sorted them out, in other words, so that, over the last twenty years, the contributions of the mind, the eye, and the hand to the creation of Reed's paintings have become increasingly disjunct. The geometric pattern of his paintings' linear design, the physical surface of colored rectangles that make this pattern visible, and the fluid gestures that sweep across that surface, have become increasingly distinct, discrete, and dissonant. The linear design of the painting has no lines. It faces us as a field of intensely colored rectangles, whose jangling, anxious intersections owe a great deal to Ellsworth Kelly and his idea that a "live painting" is arranged rather than composed. The fluid, sweeping gestures (made by the artist facing away from us) face away from us as well, appearing to us as translucent negative swaths through which the colors of the field (that faces us) remain visible.

This strategy shares a lot with the working methods of Andy Warhol, another bedroom painter who enjoyed sorting things out to keep them tense and sexy. Thus, in a Warhol, everything is always there: line and color, figure and ground, gesture and geometry, image and object, but the elements are always distinct. There is a famous story about Warhol's portrait of Henry Geldzahler (figure 13) that makes this point succinctly. It seems that Henry dropped by the Factory one afternoon while Warhol's portrait of him was on the assembly line. Andy wasn't there, but the painting was leaning against the wall. The ground colors had been applied to the canvas by one of Andy's assistants, the translucent photographic image of Geldzahler had been silkscreened onto that ground by another assistant, and Henry, thinking the painting finished, picked it up and took it home.

That night, he received a hysterical phone call from Warhol demanding that he return the painting. "Henry!" Warhol exclaimed, "You've got to bring it back. I haven't put the *art* in yet!" So Geldzahler brought the painting back. Andy added a few extravagant expressionist gestures, re-screened the image so the gestures moved over and under it, and declared the painting finished. Everything was there, but nothing was together. This is also the case with David Reed's paintings, and thinking of Reed's work in the context of a resolutely socio-political painter like Warhol, it's hard to ignore the "separation of powers" that both artists effect, or the fact that both Warhol and Reed enact in their paintings an allegory of relationships that is a virtual recipe for rough, libertarian democracy—a

figure 13
ANDY WARHOL
Henry Geldzahler 1979
silkscreen ink on synthetic polymer paint on canvas
40 x 40 inches
Estate of Henry Geldzahler

world where everything is free and separate, everything is equal, nothing holds together, but the whole is indivisible, powerful, and ominously erotic.

This brand of liberty is a private one, of course—the liberty of the bedroom—grounded in the anxieties of private pleasure and not much endorsed by our current representatives of public virtue. So, we must ask ourselves again if an exhibition of David Reed's bedroom paintings (with beds), in yet another white box, constitutes their apotheosis or merely their fate. To answer this, I think we must decide if the pleasures we derive from seeing Guidobaldo's "naked woman" in the Uffizi are worth the hypocrisy of its virtuous mystification, and the answer, I think— especially in the present moment—must be yes. Because the alternative to diluting private pleasures with public unction is the condition we now endure: a public discourse bereft of any pleasure at all. Because there is no such thing as "public pleasure." All pleasure is private, and the one true gift of Western mercantile society has always been its assumption that private pleasure and public virtue are intimately intertwined.

The permissions that David Reed's paintings dispense may, at the moment, seem as frightening in public as they are sexy in private, but so, I would suggest, were the permissions issued by the *Venus d'Urbino* in the sixteenth century. That is the point of exhibiting them in public. Earlier in this century, hundreds of museums were founded on the simple Emersonian imperative that all construction of public virtue must be tested upon the anvil of private happiness—that what we *need* and what we *want* must accommodate themselves to one another. Thus, the fact that the *Venus d'Urbino* or a painting by David Reed is diminished as it enters the public realm must be considered a small price to pay for the fact that the public discourse, in its own small way, is enhanced by accommodating itself to their presence. What's more, the private, *sotto voce* oratory of Titian and Reed is *always recoverable*, even in public, even in the box. If we can somehow feel the air as it moves around us, feel the weight of our bodies on the floor as we stand there, we can reconstitute that august environment as an ordinary location in the actual-size world. Then our eyes will go to work. We can stop looking and start to see, and, at this point, I promise, the physical paintings will come alive again and do that sexy thing they do.

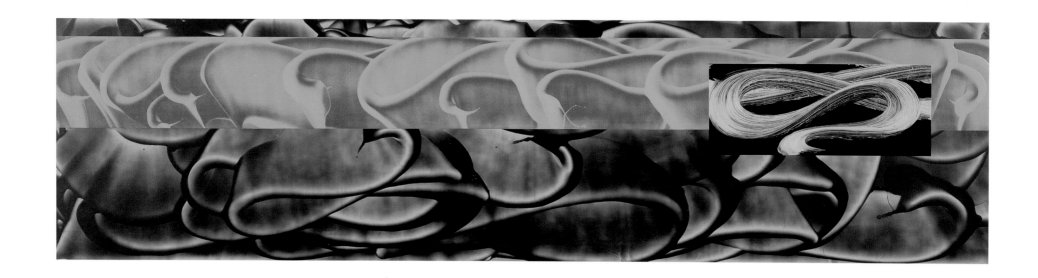

figure 14
DAVID REED
#275 1989
oil and alkyd on linen
26 x 102 inches
Collection Linda and Ronald F. Daitz

DAVID REED'S #275: A STORY OF EROTIC VISION

Mieke Bal

David Reed's painting *#275* (1989) is a horizontal strip measuring 26 x 102 inches. It is covered with forms suggesting waves, folds, or perhaps representing brushstrokes, and is quite characteristic of Reed's work (figure 14).

Usually the artist's paintings are called "abstract," and if that term is opposed to figurative, then this painting certainly is. But if abstract is used in the sense assigned to that term in other contexts, namely, to mean the opposite of tangible, then, I would argue, it is emphatically not abstract. Reed's painting is neither disembodied nor rationalistic; it is extremely sensuous. Nor is this painting expressionist; on the contrary, it opposes the whole idea of Abstract Expressionism. The surface has nothing of the tactile layering of brushstrokes that is the most distinctive mark of a certain brand of Abstract Expressionism. Nowhere is there visible evidence of the making of the painting.

The main reason why the label "abstract" sits uneasily with Reed's painting is because it is somehow, multivalently, and innovatively, narrative. A narrative can be defined as an account in whatever medium—film, language, or painting—of a series of events presented in a certain order.

Instead of marking the canvas with obvious traces of paint and paint handling, Reed offers surfaces so smooth and shiny that the eye initially bounces off them (figure 15). Thus, the events required to make a minimal narrative are already in place even in so simple and primary a reading: the eye goes to the canvas, then bounces away. But the eye soon returns, for there is something emphatically "tugging," or alluringly mysterious, in the surface. One comes to the painting with the wrong expressionist, tactile assumptions, is disconcerted, and then is drawn back into the surface on new terms. At this point, the second "episode" of looking takes place, one that engages the eye in a different kind of tactility. This time, the eye lingers, subjectively creating another sense of time.

Without the false start, the effect replacing the expected one would not so easily take hold. This is one of the reasons why, here and there, the waves are made to "look like" brushstrokes, to represent them—emphasizing that they only evoke brushmarks, without being them. Representation replaces expression. In the initial viewing, the brushstrokes are evoked as in a third-person, not a first-person, narrative. It is only then, after this experience, that another can be offered. For lack of a better word, I call this alternative tactility "erotic." It is this erotic engagement that glues the eye to the surface.

Visual erotics, as distinct from expressionism, are not based on the inscription of the "I" in the work, but on the inscription of the strongest possible dynamic between the "I" and the "you"—grounded in a sense-based attraction that is not limited to vision. Instead of appreciating tactile roughness as evidence of the maker's hand, one wants to caress or lick Reed's smooth surfaces.

My interpretation of Reed's *#275* is based on a particular genre or mode of narrative, a seldom used one that is perceived as artificial or experimental—that of narrative in the second person. Instead of first- or third-person narrative which uses the "I" or the "he/she," second-person narrative uses the "you," thereby implying an intimate relationship between the painting and the viewer.

One way to enter Reed's mode of painting and its specific eroticism is to read his waves as folds. In his translator's introduction to Deleuze's *The Fold, Leibniz and the Baroque,* Tom Conley sums up what makes Baroque forms so enticing:

> *. . . an intense taste for life that grows and pullulates, and a fragility of infinitely varied patterns of movement. . . . in the protracted fascination we experience in watching waves heave, tumble, and atomize when they crack along an unfolding line being traced along the expanse of a shoreline; in following the curls and wisps of color that move on the surface and in the infinite depths of a tile of marble. . . .*

The vocabulary here is mostly formal and aesthetic, describing forms and their infinite expandability. But the aesthetic itself is based on terms that

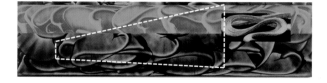

figure 15
#275 (detail 1) 1989

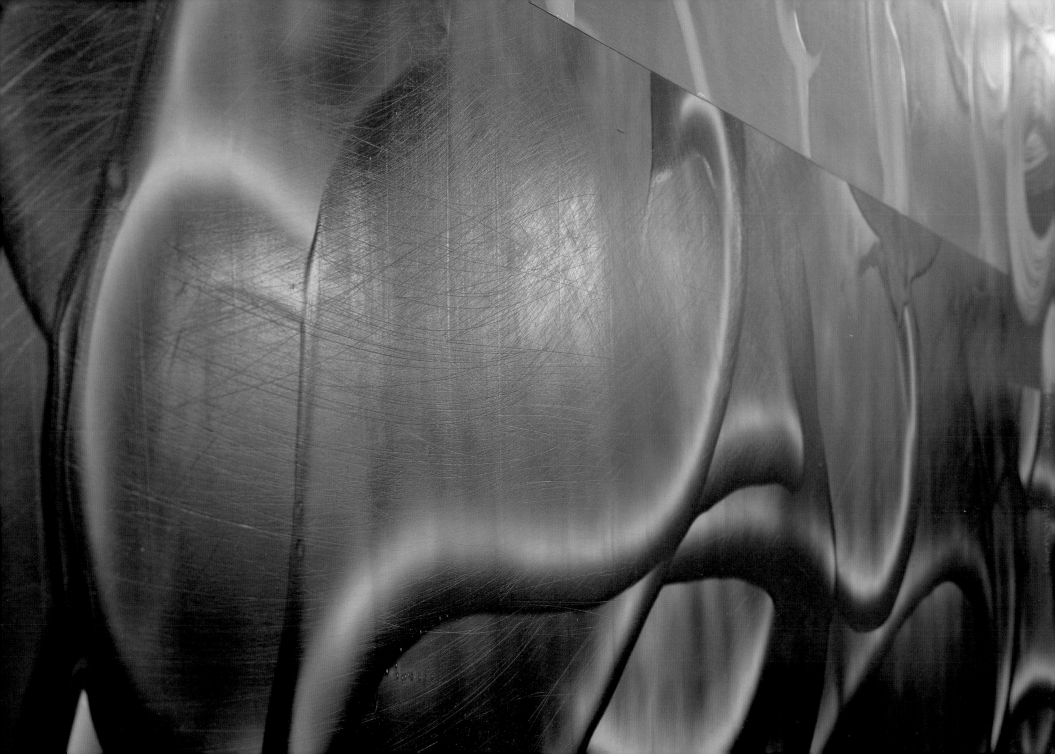

underscore a relation to second-person narrative. Phrases like "we experience" cast the viewer as integral to the meaning. There is the suggestion of an intimate link between the forms that fascinate and the "intense taste for life that grows and pullulates." If that pullulating life is situated in the painting, now a first person saying "you" to the viewer, and if the "experience" of forms is situated on the side of the viewer, the second person "you" being addressed, then the exchange that occurs when this aesthetic happens is itself what initiates and structures the aesthetic.

Seen through this formulation of Baroque aesthetics, second-person narrative is present in Reed's *#275* on multiple levels. Indeed, his waves or folds "heave, tumble, and atomize when they crack along an unfolding line being traced along the expanse of a shoreline" (figure 16). And the emphatically horizontal format of the work underscores just that sensation. Like the waves reaching the shoreline, the waves that constitute this painting solicit the protracted fascination that immerses us as viewers in the passing of time, as we are seduced to follow the sensuous and meandering shapes, the lines that lead nowhere. Like a film, the image scrolls by, simulating a live seascape. Moreover, the extreme width makes it impossible to take the painting in at a glance; no single Gestalt can embrace it.

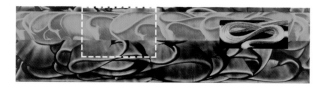

figure 16
#275 (detail 2) 1989

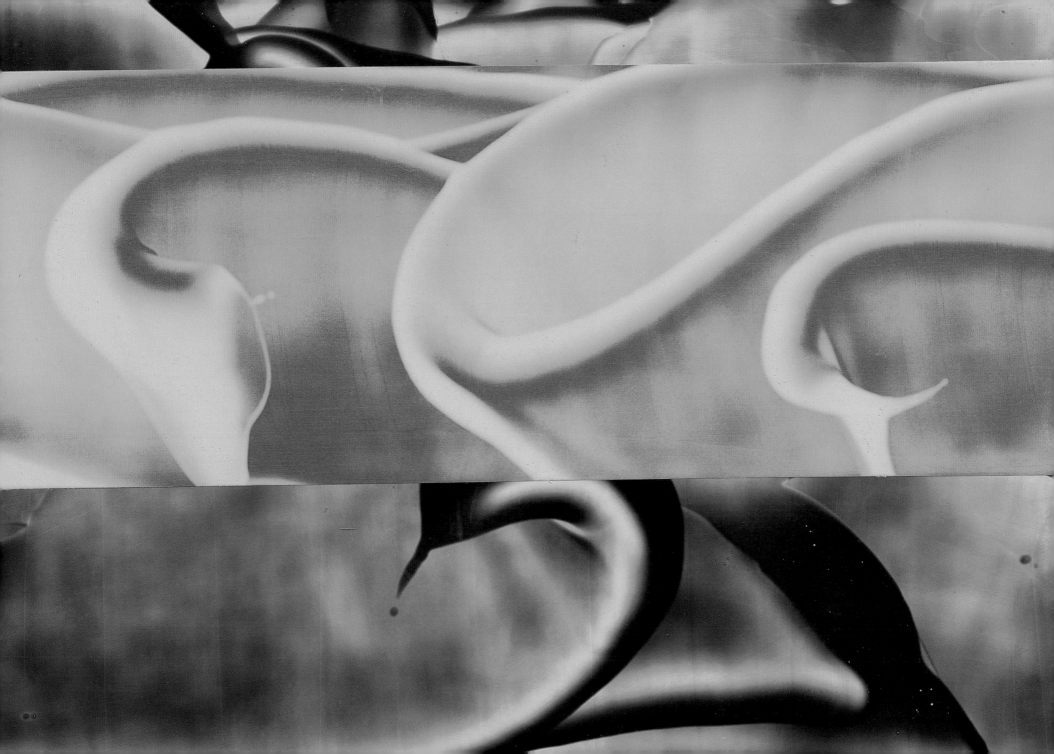

The folds are also "pullulating" into a third dimension, in a way that attracts the viewer to travel up and down the hills of the folds, inside and out. And it is this represented three-dimensionality that is specifically to be interpreted as the dance of eroticism (figure 17).

A comparison with any number of paintings by Caravaggio can further illuminate this seductive effect that is neither primarily intellectual nor lyrical, but sensual—or rather, that overcomes those artificial distinctions altogether. The attraction of the human body in many of Caravaggio's paintings, erotic as it may appear, is accomplished by means of waves, folds, and textures that totally lack the inscription of the artist's hand, whereby the figure comes forward to invite and accommodate the phantasmic touch.

The innovations Caravaggio introduced made him a forerunner, an avant-garde artist of his time. To be of his time, to make contemporary work, Reed demonstrates a profound, nonrivalrous engagement with Caravaggio. Reed takes Caravaggio's play of light and shadow, volume and form and makes them relevant to the late twentieth century through a relation to photography in the literal sense of "light-writing." Photography's power is the inscription of the presence of the object in the photograph, like a signature, written there in the present but also fatally inscribed to the past.

The elimination of representational figuration enables Reed to draw and paint with light in the same way Caravaggio did, although without recourse to the attractive body of a handsome youth. Reed's painting, not abstract but also nonfigurative, is exceedingly realistic and illusionistic. This, its surface proclaims, is realism. However, since there is nothing represented, it is just a method without an object. Caravaggio, the history of painting, Baroque folds, and the erotics of surface are *in* this work as its past. Thus, Reed's painting *represents* not figures, as figurative painting does, but the theory of light-writing that it enacts; it thematizes what, in light-writing, *matters*. There are no shapes with edges, no outlines; the light now is the shape, creates it, and constitutes its climactic point.

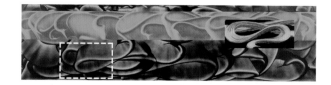

figure 17
#275 (detail 3) 1989

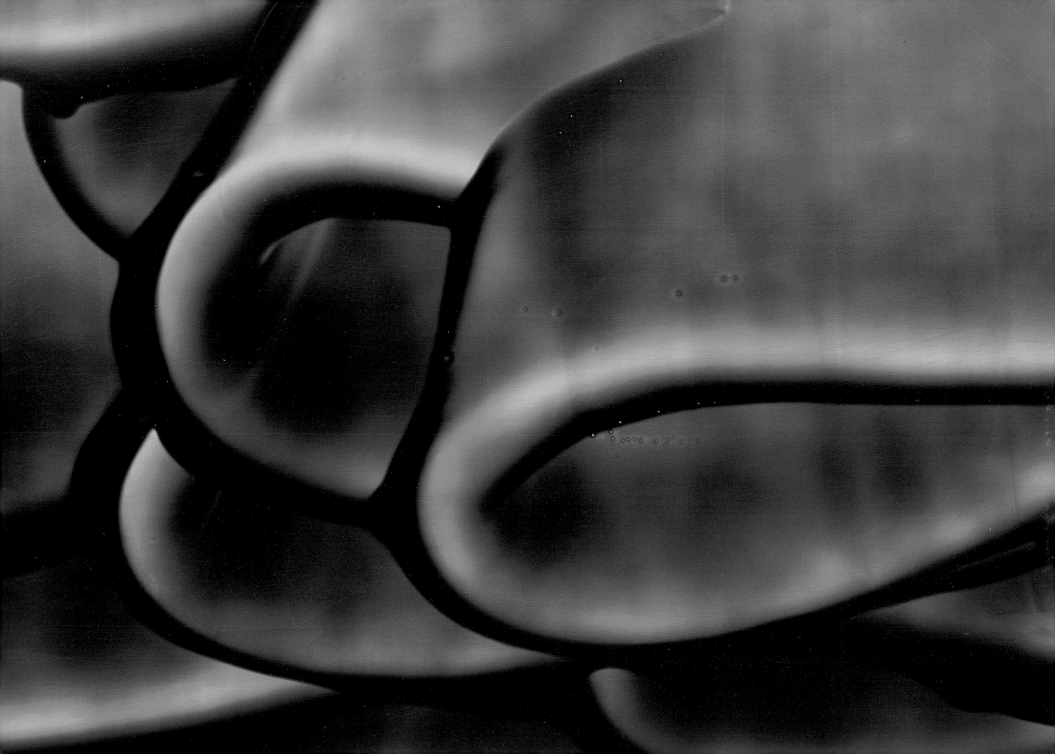

The means by which the erotic effect of Reed's *#275* is achieved is light, the least material of the painter's means, and also the most emphatically distinct from the heaviness of paint as substance. In this painting, light is abducted for the engagement of the senses. The representational modeling of light on a figure is replaced by the dialectic between the presence and absence of light on the surface of the painting. The surface is formed using the same method, modeling, and the same substance, transparent paint, that "gave body" to the figure. Light is used for both modeling and substantiating the image. The simultaneous manifestation of two-dimensional surface and three-dimensional fullness connects our visual attraction to this flat surface and our infinitely touchable three-dimensional body. Light signifies the most tender and slight, yet most thrilling, kind of touch (figure 18).

Reed draws, paints, and sculpts from within the body, a body that is not there to see but overwhelmingly there to be. The paint is not only the skin, but also the blood pulsing underneath it; it is more than skin-deep. The light pushes up from within. Thus the light defines the surface as moving toward the viewer so that he or she, saying "you" to the surface, can come into his or her status as a bodily engaged "I." We connect to the skin of the painting through our own skin, the largest and most intensely feeling sense organ.

figure 18
#275 (detail 4) 1989

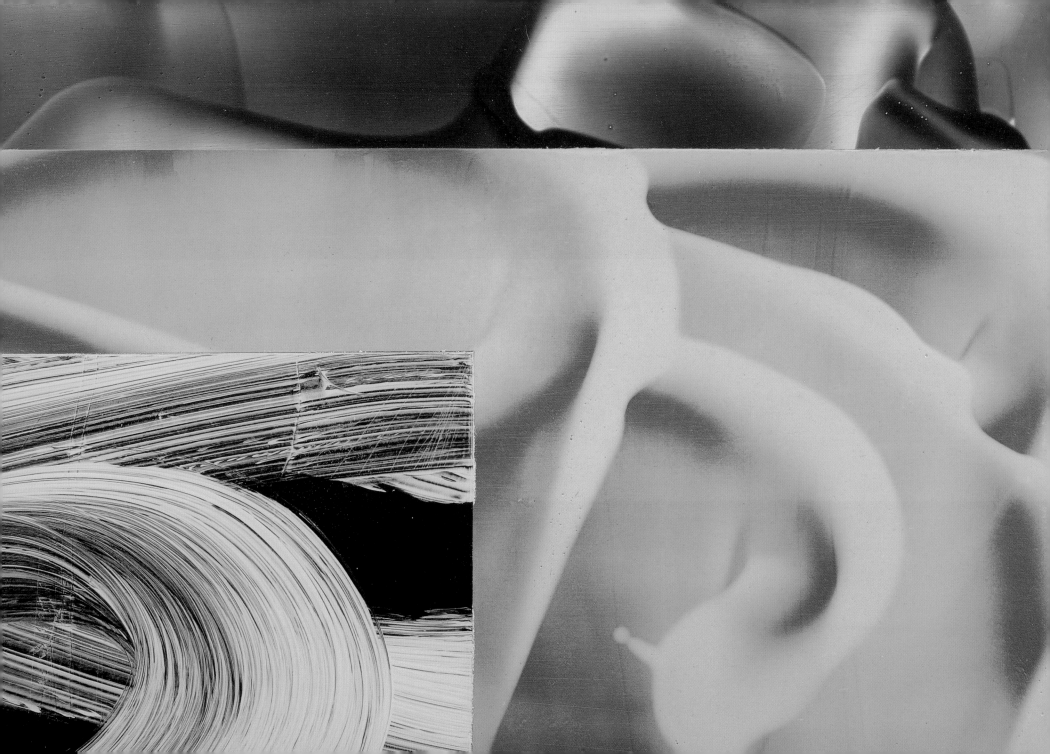

There is one particular area in Reed's painting that especially emphasizes the sensual fullness of light. This is the area in the central band on the right side, where the waves or folds are broader and their edges closer to one another (figure 19). The overall erotic effect of the painting is enhanced here by an increased level of sensuality, enfolding the eye and holding it a bit longer so the luxurious experience of time surfaces into consciousness. One of the signs that makes this portion stand out is the very end of the brushmark, the end of its lowest curl, where it meets the lower band of the painting. The end of this mark resembles a comma.

figure 19
#275 (detail 5) 1989

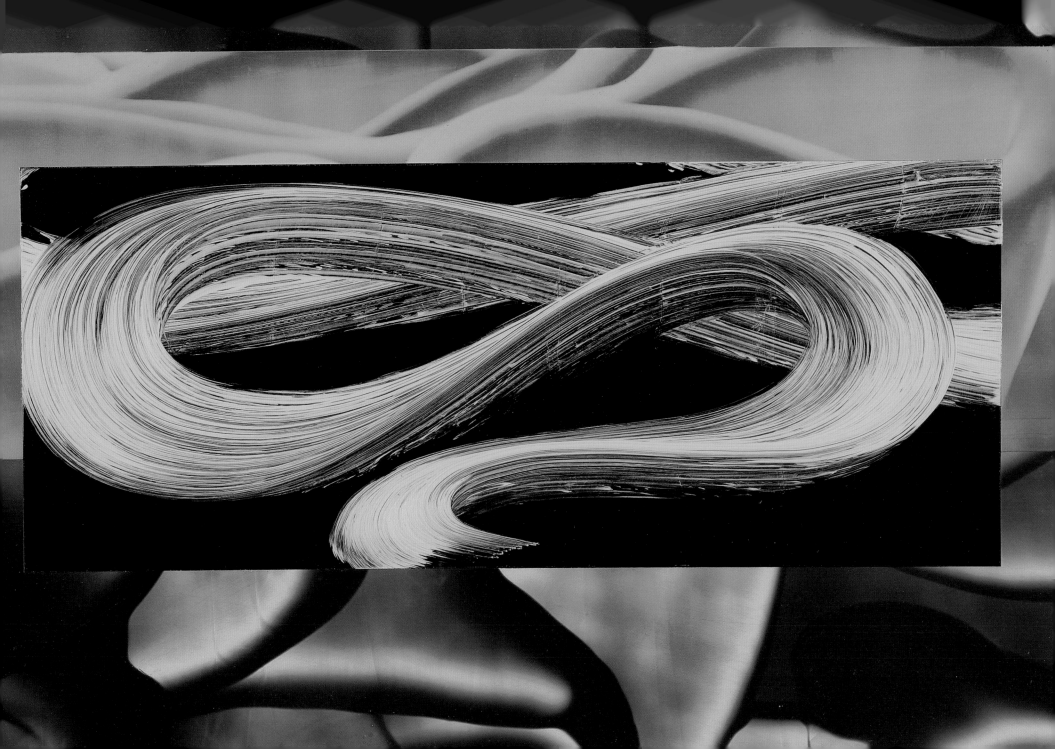

It seems significant that this comma, ending the single, largest, densest and thickest set of folds in the painting, is the only place where any of the waves or folds seem to have stopped. Yet this ending takes the shape of a sign that, in writing, signifies not-ending, a sign that there is more to come. And this linguistic non-ending is visually represented by the brushmark disappearing as it crosses over the border (figure 20). The line separating painted areas, the line formed by the edge of a fold, and the punctuation mark in the line of a sentence: the "fragility of infinitely varied patterns of movement" is enacted here.

The initial episode of bouncing back is but the first step in the narrative of vision that is this painting. The false start is necessary to re-key the viewer whose cultural baggage has limited his or her range of visual possibility. In the erotic attraction of the second episode, the viewer cannot help but return to the beckoning light and welcoming folds that offer to envelop "you" in their caress. But then, this eroticism, powerful and indispensable as it is, is also just a second episode, followed by others. For the power of eroticism is that it can teach us things that lie beyond the erotic. There is a variation in the relation between what you are and what you see, a variation that is not stable but in process—an ongoing narrative.

figure 20
#275 (detail 6) 1989

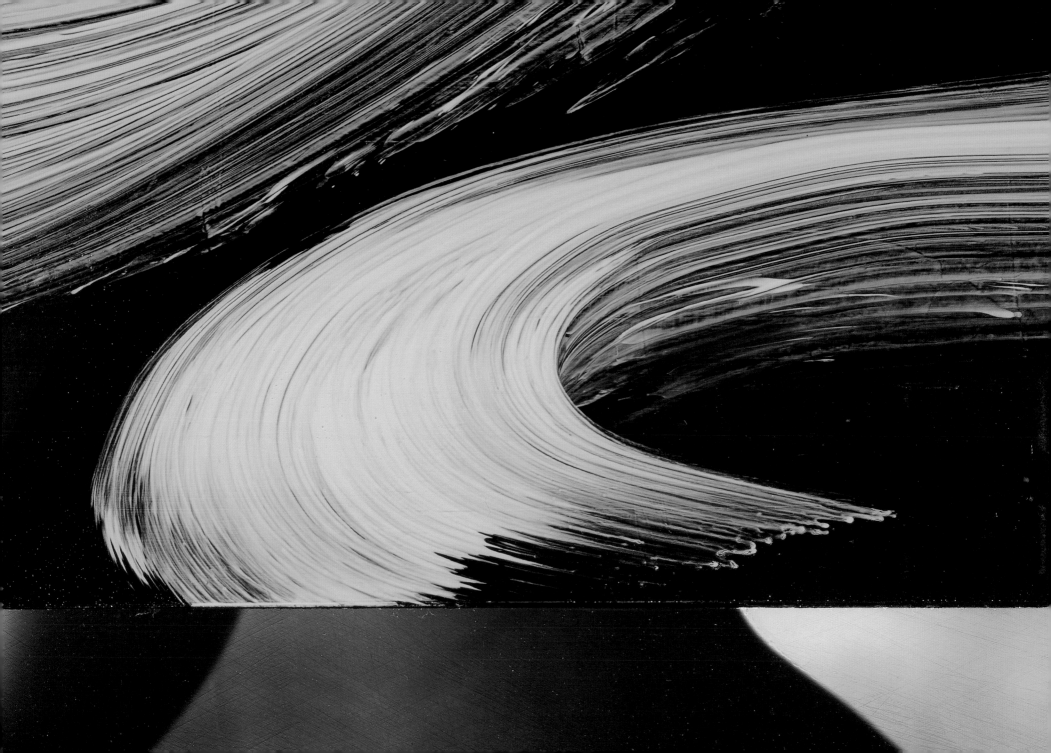

PLATES

DAVID REED PAINTINGS
MOTION PICTURES

DAVID REED PAINTINGS

MOTION PICTURES

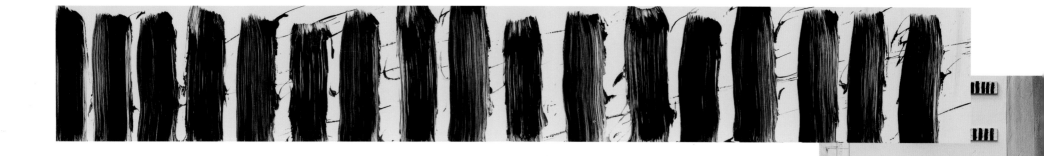

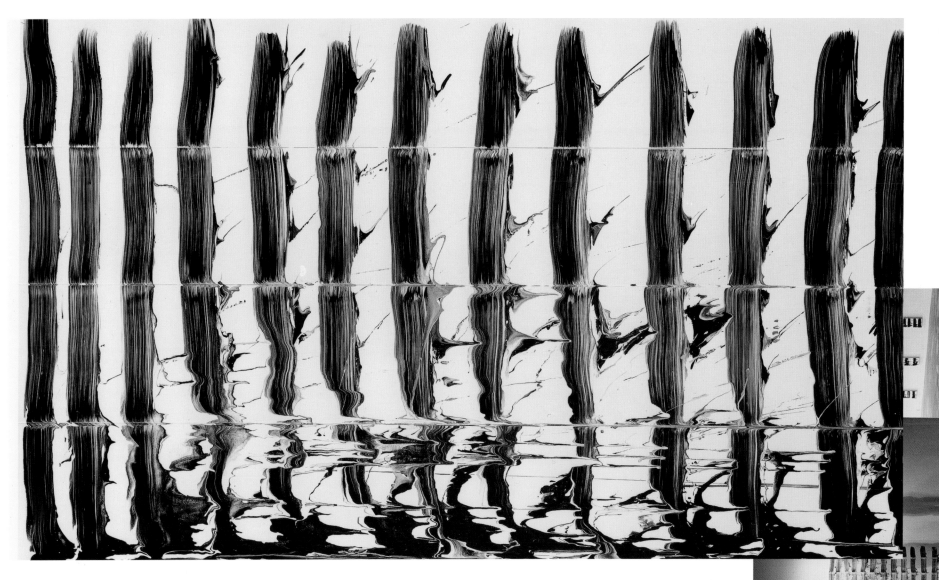

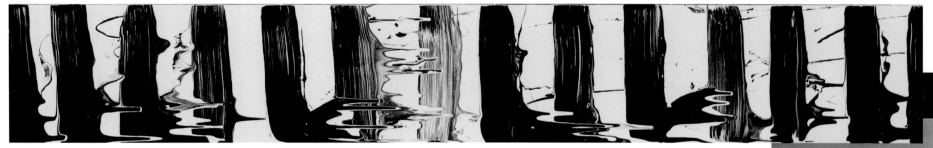

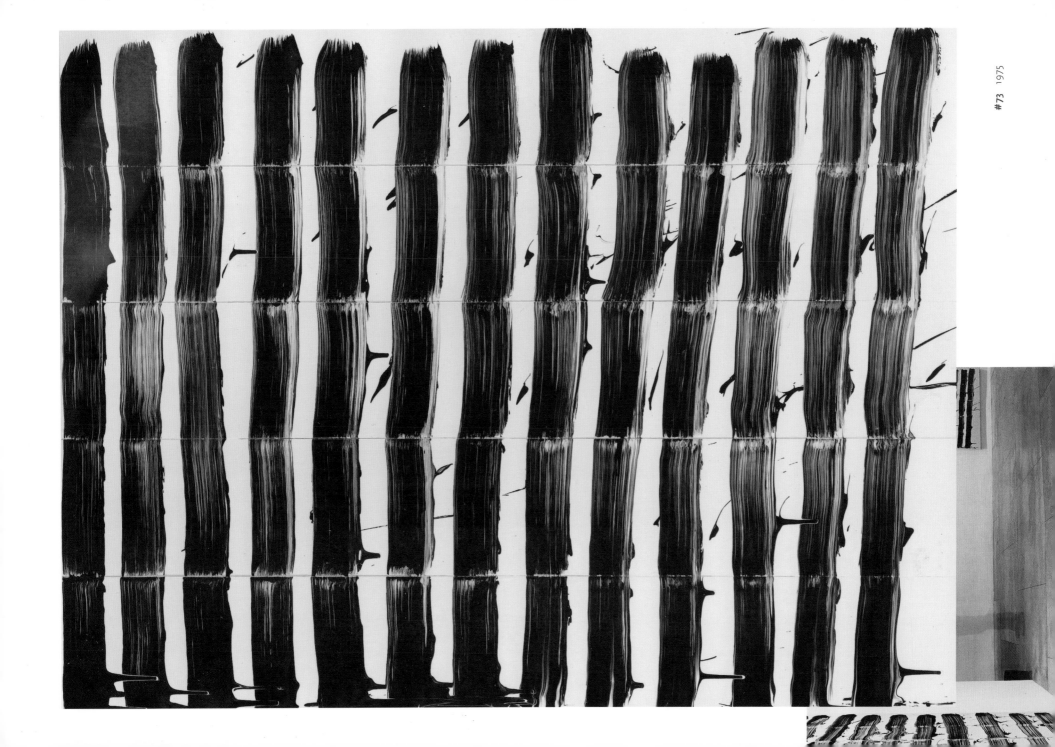

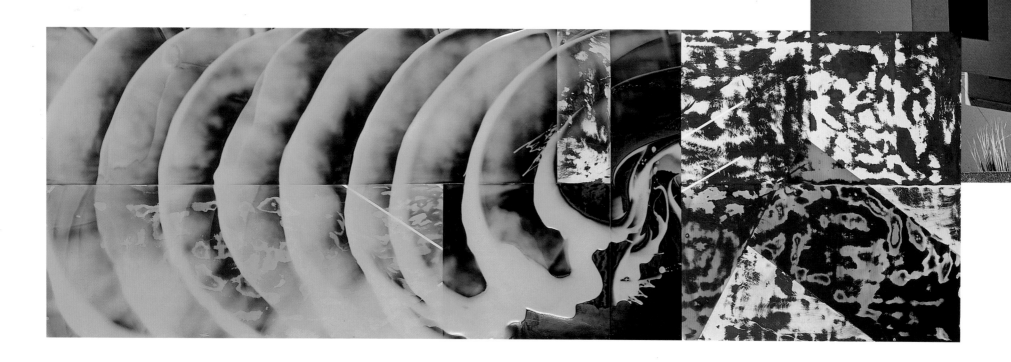

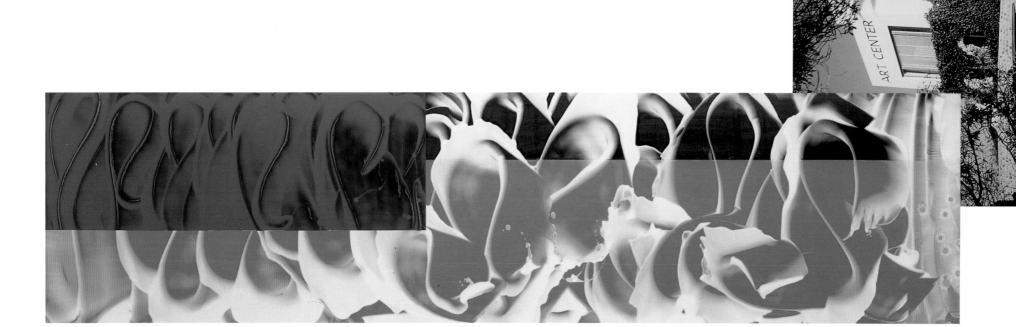

ART CENTER

#264 1988

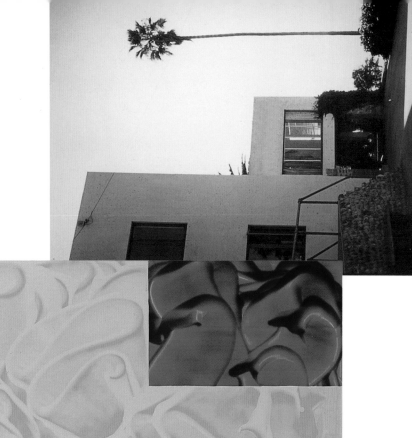

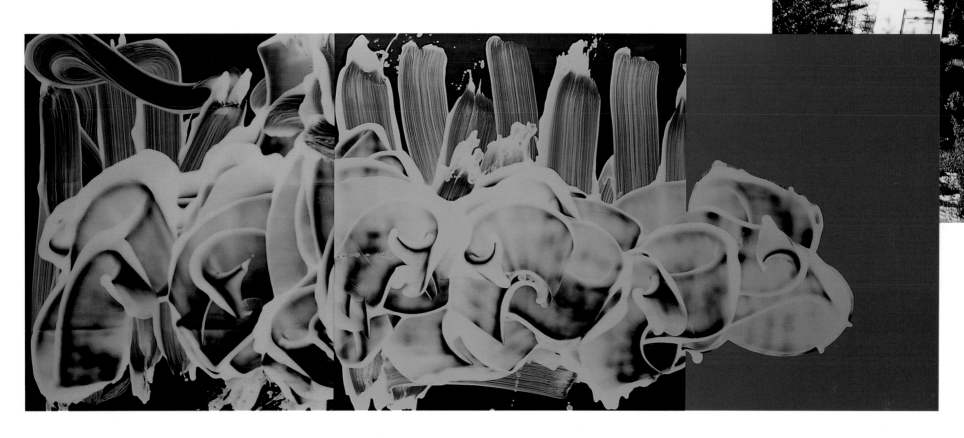

#**323** 1990—93

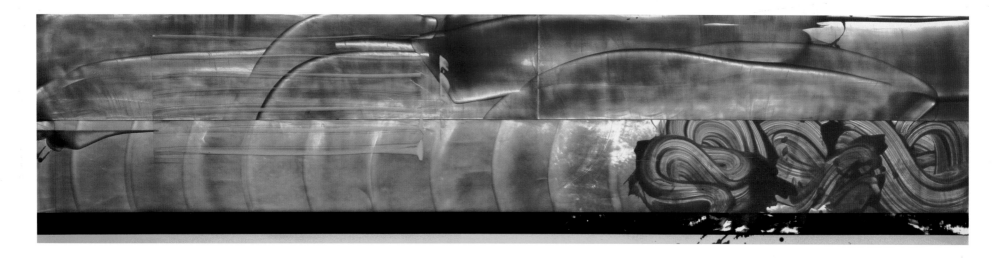

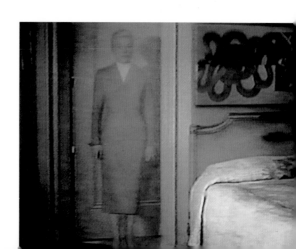

#212 (Vice) 1984–85

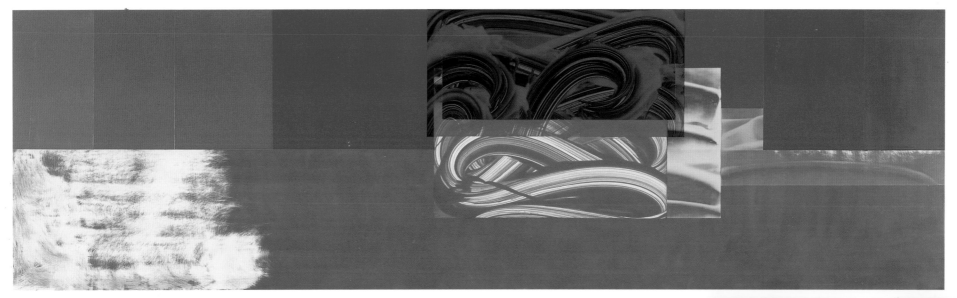

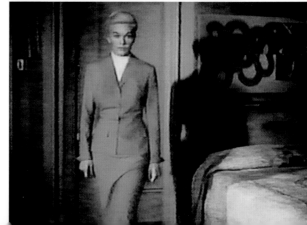

#228 1986

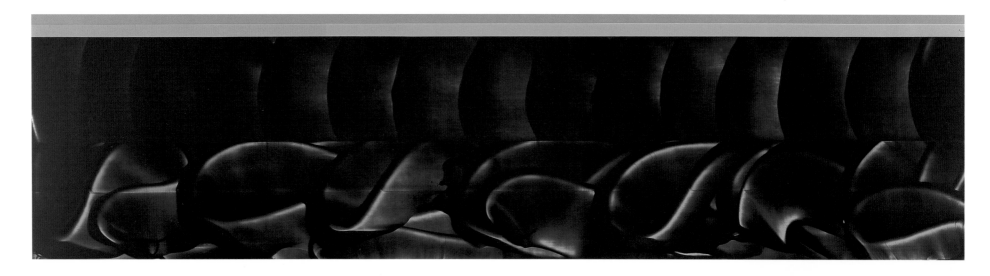

#247 1987

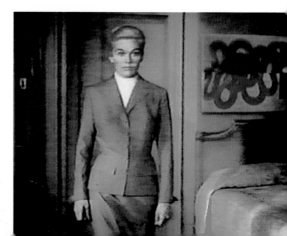

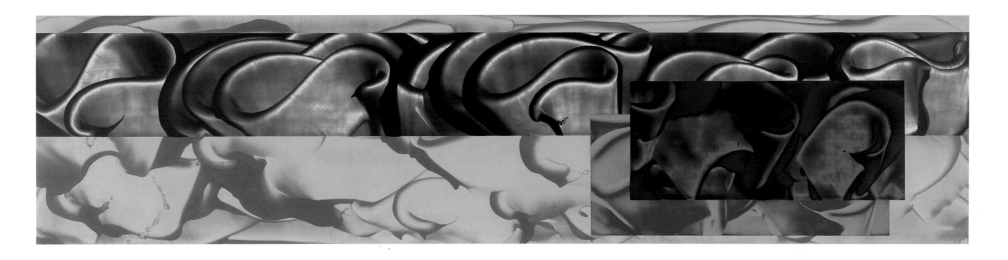

#266 1987–88

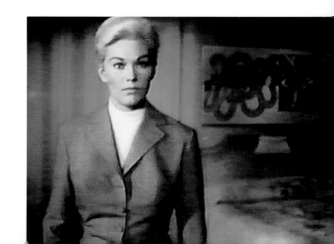

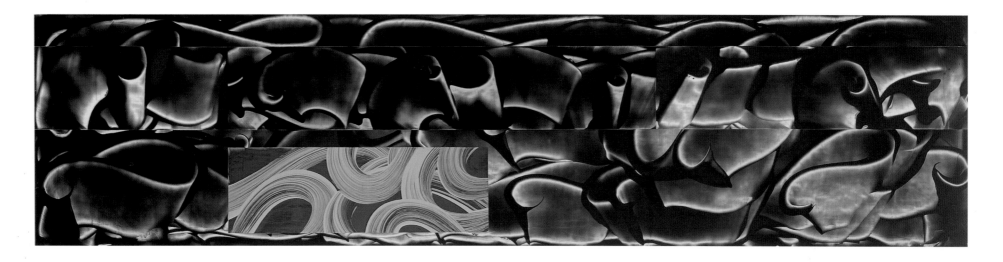

#292 1989–91

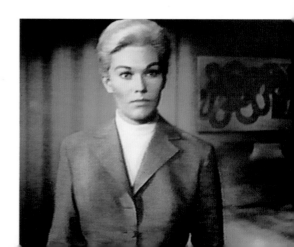

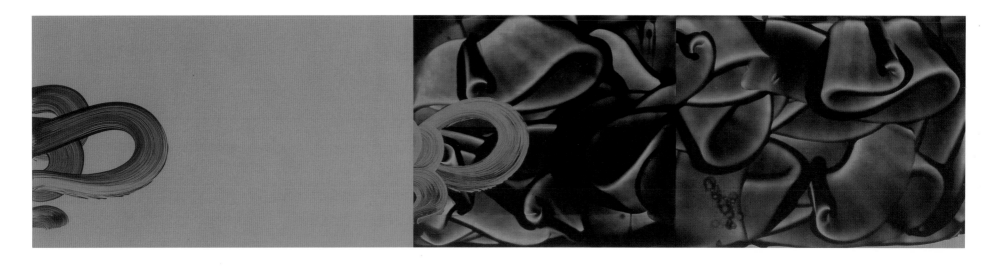

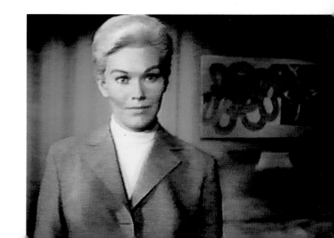

#307 1991–92

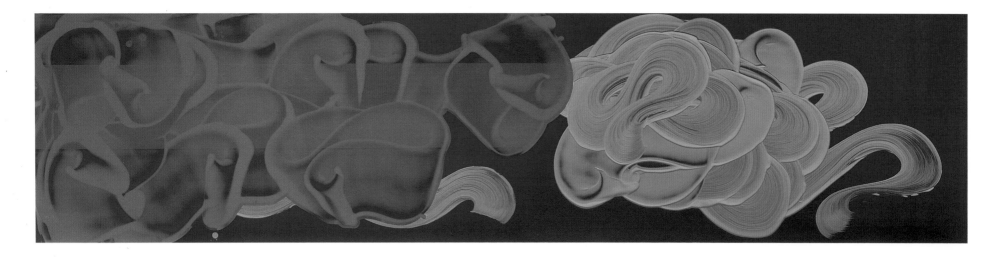

#332 1993–94

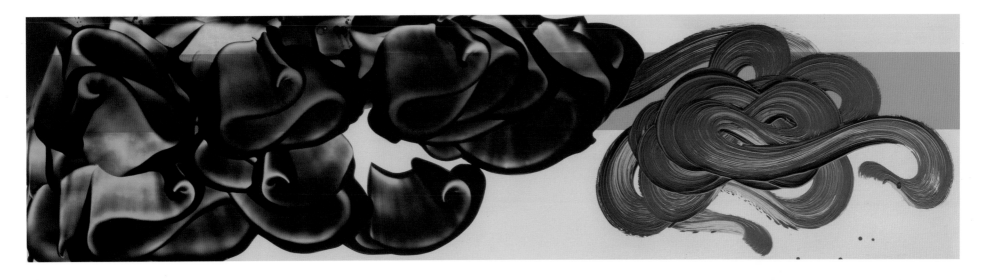

#345 1992–96

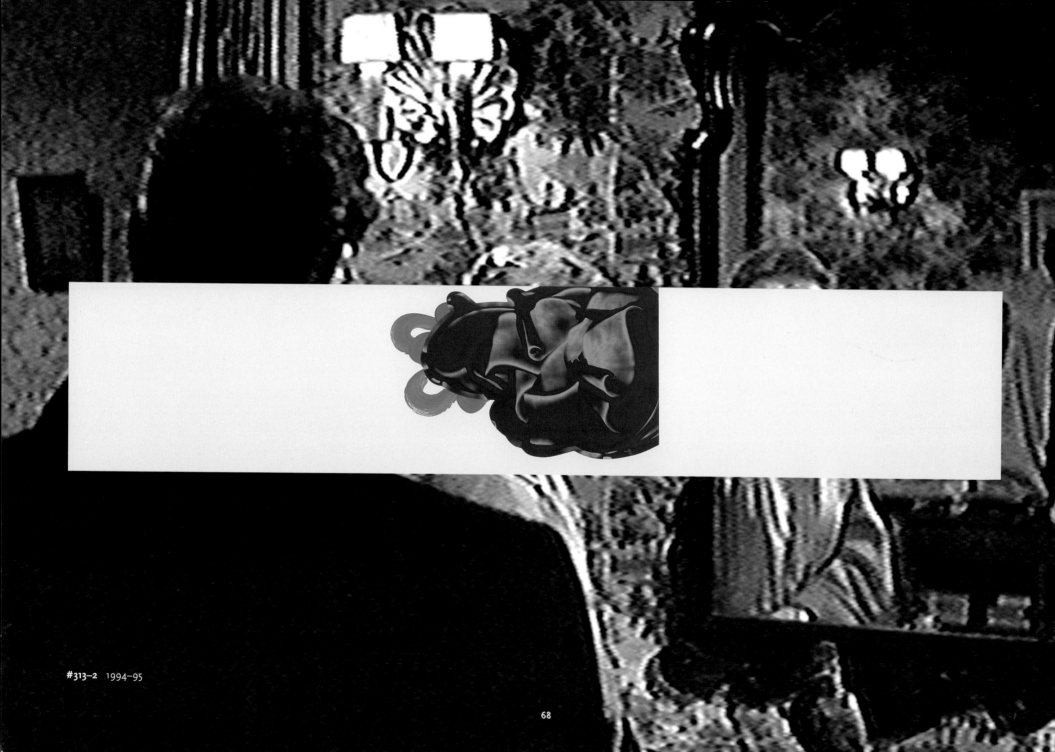

#313-2 1994-95

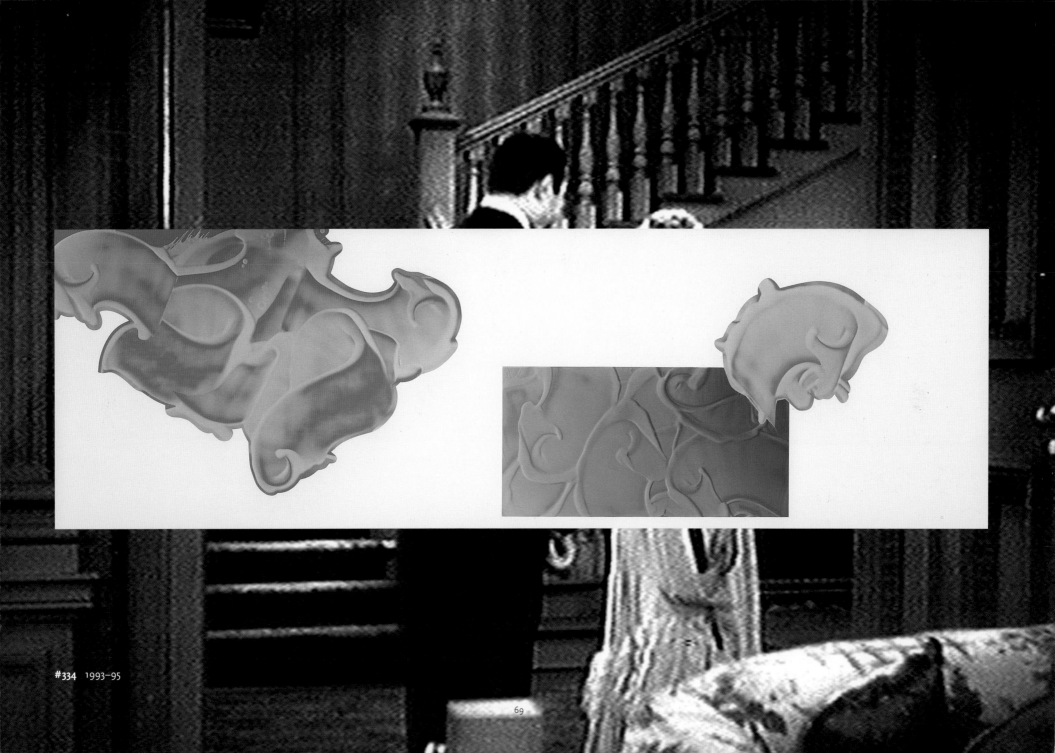

#334 1993–95

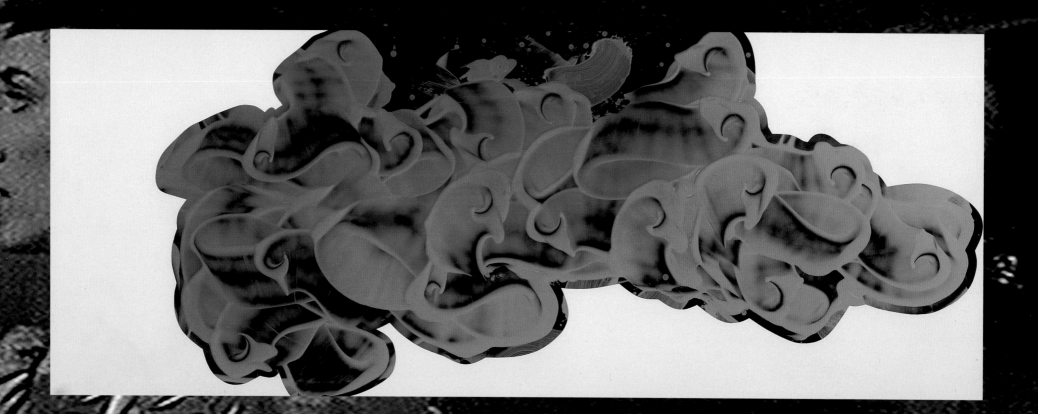

#337 1994

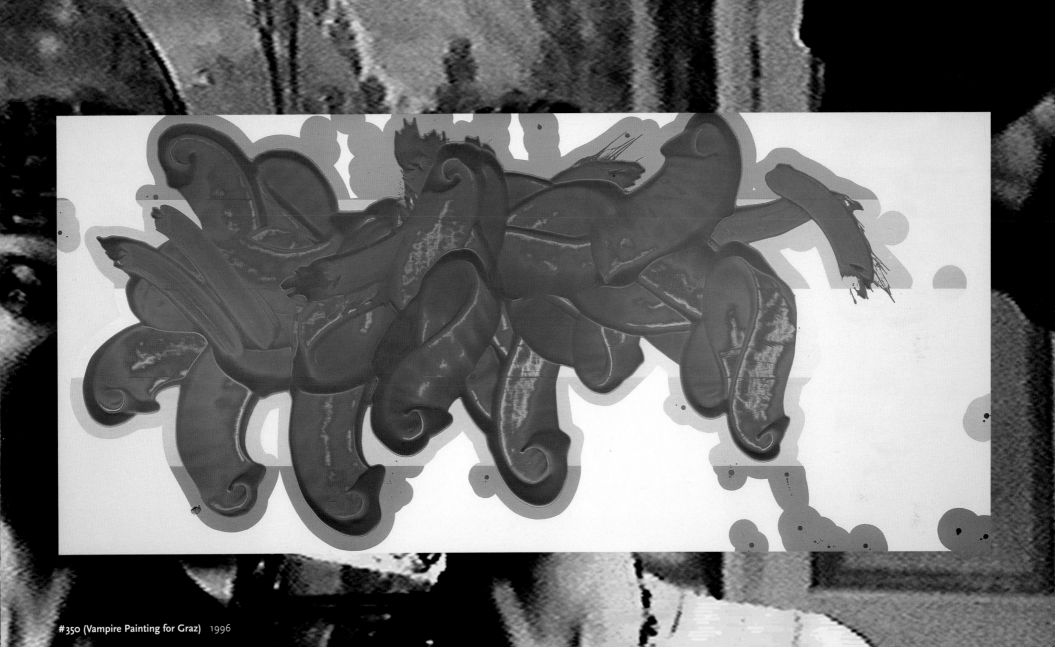

#350 (Vampire Painting for Graz) 1996

LIST OF PLATES

**All works of art by David Reed,
unless otherwise noted.
Height precedes width.**

pages 52–55 (lower left)
4 views of exhibition of paintings
by David Reed at the Susan Caldwell
Gallery, New York, in 1975

page 52
#37 1974
oil on canvas
76 x 11 inches
Collection John Reed

page 53
#42 1974
oil on canvas
76 x 44 inches
Collection the artist

page 54
#43 1974
oil on canvas
76 x 11 inches
Collection Robert Shapiro

page 55
#73 1975
oil on canvas
76 x 56 inches
Centre National d'Art et de Culture
Georges Pompidou, Paris

pages 56–59 (lower right)
4 photographs of the La Jolla Art Center
(formerly Scripps House designed
by Irving Gill, and now Museum
of Contemporary Art, San Diego)
taken by John August Reed in 1947

page 56
#202–2 1981–83
oil and alkyd on canvas
108 x 36 inches
Collection Mr. and Mrs. Herb Edelberg

page 57
#264 1988
oil and alkyd on linen
112 x 28 inches
Collection Harry W. and Mary Margaret
Anderson

page 58
#283–2 1989–91
oil and alkyd on linen
112 x 28 inches
Collection Rolf Ricke, Cologne

page 59
#323 1990–93
oil and alkyd on linen
112 x 46 inches
Private collection, Bad Homburg
v.d.H., Germany

pages 60–67 (lower right)
8 frame stills from videotape:
DAVID REED
**Two Bedrooms in San Francisco,
Judy's Bedroom** 1994
featuring painting *#328* inserted into
Alfred Hitchcock's film *Vertigo*,
Universal Pictures, 1958

page 60
#212 (Vice) 1984–85
oil and alkyd on linen
24 x 96 inches
Collection Marjorie and Charles
Van Dercook

page 61
#228 1986
oil and alkyd on linen
28 x 96 inches
Private collection

page 62
#247 1987
oil and alkyd on linen
27 x 108 inches
Collection Diane and Steven Jacobson

page 63
#266 1987–88
oil and alkyd on linen
24 x 102 inches
Collection Mr. and Mrs. E. Davisson
Hardman, Jr., China

page 64
#292 1989–91
oil and alkyd on linen
28 x 116 inches
Collection Diane and Steven Jacobson

page 65
#307 1991–92
oil and alkyd on linen
26 x 108 inches
Collection Phyllis and Richard Cantor,
New York

page 66
#332 1993–94
oil and alkyd on linen
26 x 110 inches
Courtesy Max Protetch Gallery,
New York

page 67
#345 1992–96
oil and alkyd on linen
26 x 102 inches
Courtesy the artist and
Max Protetch Gallery, New York

page 68 (foreground)
#313–2 1994–95
oil and alkyd on linen
28 x 144 inches
Collection Rolf Ricke, Cologne

page 68 (background)
frame still from **The Return
of Dracula** 1958
Directed by Paul Landres,
Levy-Gardner Production/United
Artists

page 69 (foreground)
#334 1993–95
oil and alkyd on linen
34 x 110 inches
Sammlung Goetz, Munich

page 69 (background)
frame still from **Dracula** 1931
Directed by Tod Browning,
Universal

page 70 (foreground)
#337 1994
oil and alkyd on linen
50 x 130 inches
Collection Dr. Carl Grover

page 70 (background)
frame still from **Bram Stoker's
Dracula** 1992
Directed by Francis Ford Coppola,
Columbia / American Zoetrope /
Osiris Film

page 71 (foreground)
#350 (Vampire Painting for Graz) 1996
oil and alkyd on linen
54 x 118 inches
Sammlung Goetz, Munich

page 71 (background)
frame still from **Warhol's Blood
for Dracula** 1973
Directed by Paul Morrissey,
Pierre Rassam / Warhol Productions

#34 1974
oil on canvas
76 x 12 inches
Collection Mrs. Albert L. Anderson

#37 1974
oil on canvas
76 x 11 inches
Collection John Reed

#42 1974
oil on canvas
76 x 44 inches
Collection the artist

#43 1974
oil on canvas
76 x 11 inches
Collection Robert Shapiro

#49 1974
oil on canvas
76 x 44 inches
Collection the artist

#52 1974
oil on canvas
76 x 11 inches
Collection Beverly and David Reed

#147 1979
acrylic on canvas
10 x 108 inches
Collection Museum of Contemporary
Art, San Diego
Gift of Ruth and Harry Guffee

#187–3 1982–84
oil and alkyd on linen
24 x 96 inches
Collection Robin and Fred Warren

#202–2 1981–83
oil and alkyd on linen
108 x 36 inches
Collection Mr. and Mrs. Herb Edelberg

#212 (Vice) 1984–85
oil and alkyd on linen
24 x 96 inches
Collection Marjorie and Charles
Van Dercook

#222–2 1984–86
oil and alkyd on linen
24 x 102 inches
Collection the artist

#228 1986
oil and alkyd on linen
28 x 96 inches
Private collection

#238 1986–87
oil and alkyd on linen
25 x 100 inches
Christa and Wolfgang Häusler

#247 1987
oil and alkyd on linen
27 x 108 inches
Collection Diane and Steven Jacobson

#264 1988
oil and alkyd on linen
112 x 28 inches
Collection Harry W. and Mary Margaret
Anderson

#275 1989
oil and alkyd on linen
26 x 102 inches
Collection Linda and Ronald F. Daitz

#276 (for Nick) 1989
oil and alkyd on linen
24 x 102 inches
Collection Barbara and Howard Morse

#279 1987–89
oil and alkyd on linen
108 x 48 inches
Collection Irwin and Beth Robbins

#283–2 1989–91
oil and alkyd on linen
112 x 28 inches
Collection Rolf Ricke, Cologne

#292 1989–91
oil and alkyd on linen
28 x 116 inches
Collection Diane and Steven Jacobson

#316 1992
oil and alkyd on linen
107 7/8 x 36 inches
Private collection, Cologne

#323 1990–93
oil and alkyd on linen
112 x 46 inches
Private collection, Bad Homburg
v.d.H., Germany

#328 1990–93
oil and alkyd on linen
29 x 56 inches
Private collection, Cologne

#332 1993–94
oil and alkyd on linen
26 x 110 inches
Courtesy Max Protetch Gallery, New York

#334 1993–95
oil and alkyd on linen
34 x 110 inches
Sammlung Goetz, Munich

#337 1994
oil and alkyd on linen
50 x 130 inches
Collection Dr. Carl Grover

#339 1994
oil, alkyd and silkscreen on linen
130 x 50 inches
Collection Pauline and Stanley Foster

#345 1992–96
oil and alkyd on linen
26 x 102 inches
Courtesy the artist and Max Protetch
Gallery, New York

#350 (Vampire Painting for Graz) 1996
oil and alkyd on linen
54 x 118 inches
Sammlung Goetz, Munich

#351 (#10–2) 1995–97
oil and alkyd on Solid Ground
13 1/8 x 22 inches
Courtesy Patricia Faure Gallery,
Santa Monica, California

#351 (#20) 1996–97
oil and alkyd on Solid Ground
13 1/8 x 22 inches
Collection Alisa Tager and David Pagel

#356 (#20) 1996
oil and alkyd on Solid Ground
8 1/2 x 27 7/8 inches
Collection Linda Yeaney

#356 (#22) 1996
oil and alkyd on Solid Ground
10 1/2 x 22 7/8 inches
Collection Eloisa and Chris
Haudenschild

#356 (#23) 1996
oil and alkyd on Solid Ground
8 1/2 x 27 7/8 inches
Collection Irina Alimanestianu-Chao

#357 (#2) 1996
oil and alkyd on Solid Ground
5 7/8 x 8 inches
Collection Monique Prieto and
Michael Webster

#357 (#5) 1996
oil and alkyd on Solid Ground
8 x 5 1/4 inches
Collection Ingrid Calame

#383 (#2) 1997
oil and alkyd on Solid Ground
6 1/4 x 12 inches
Courtesy Patricia Faure Gallery,
Santa Monica, California

#416 1998
oil and alkyd on Solid Ground
6 1/8 x 10 7/8 inches
Collection Steven Hull

#428 1998
oil and alkyd on linen
Courtesy the artist and Max Protetch
Gallery, New York

#429 1998
oil and alkyd on linen
Courtesy the artist and Max Protetch
Gallery, New York

Judy's Bedroom 1992
variable painting featured: *#328*
bed, bedding, bedspread, headboard,
lamp, videotape: **Two Bedrooms in
San Francisco, Judy's Bedroom**, 1994,
featuring painting *#328*, inserted
into Alfred Hitchcock's film *Vertigo*,
Universal Pictures, 1958
dimensions variable
Courtesy the artist and Galerie Rolf
Ricke, Cologne

Scottie's Bedroom 1994
variable painting featured: *#345*
bed, bedding, bedspread, headboard, lamp,
robe, videotape: **Two Bedrooms in San
Francisco, Scottie's Bedroom**, 1994,
featuring painting *#345*, inserted
into Alfred Hitchcock's film *Vertigo*,
Universal Pictures, 1958
dimensions variable
Courtesy the artist and Max Protetch
Gallery, New York

Sunset Room for Vampires 1998
variable paintings featured: *#334, 337, 350, 428*
mixed media, frame stills, videotape
dimensions variable
Courtesy the artist and Galerie Rolf
Ricke, Cologne

Sun Parlor for Ellen Browning Scripps 1998
variable painting featured: *#429*
mixed media, live video projection
dimensions variable
Courtesy the artist and Max Protetch
Gallery, New York

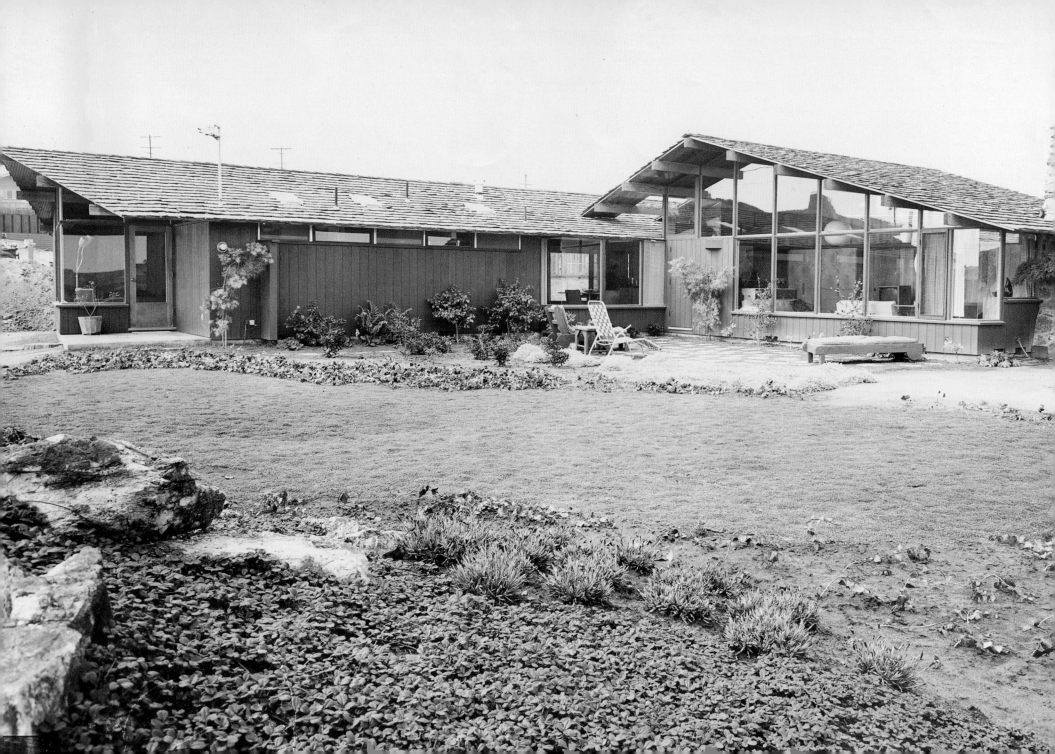

1946

Born in the sunroom of grandparents' house, Alta Mira Street, Missions Hills, San Diego.

1949

First memory: touching red, yellow, and blue wooden beads while looking at patterns of sunlight on the peach-colored stucco wall of parents' house on Alicia Street, Point Loma.

1950

Waters flowers with grandfather outside sunroom. Splashes reflect sunlight and color.

1951

Sick with the measles in a darkened pale blue room, when newborn sister, Pamela, is brought to her pink room.

1952

First television set on Alicia Street: watches Hopalong Cassidy, the Cisco Kid, and Charlie Chan.

1954

Father's forest green MG exchanged for a pale lemon Dorreti.

1956

With sister, chooses favorite colors and patterns from deck of cards, *House of Cards,* designed by Charles and Ray Eames.

1951–58

Travel with family to National Parks in the Southwest and to mother's family in Arkansas, sometimes in red and white '57 De Soto.

With grandfather goes to circuses and magic performances: sees Blackstone cut a woman in half at the El Cortez Hotel.

Classes at the Art Museum, Natural History Museum, and Zoo in Balboa Park: frightened by severed ear in *Christ Taken Captive,* copy after Hieronymus Bosch.

1956

Family moves into modernist house in Point Loma designed by Uncle John August Reed: living room oriented to winter sunlight (figure 21). Abstract paintings by Aunt Rosemary and Uncle O. P. Reed and figurative paintings by Great Uncle August Biehle leave ghost marks where wooden walls not faded by the sun.

1958–63

Races snipes and sabots at the Mission Bay Yacht Club.

1959

With family visits Rosemary and O.P. and their family in Nichols Canyon, Los Angeles. Sees O.P.'s paintings in progress on the floor of his studio. Later visits their house on the beach in Malibu and sleeps on a bunk bed in a room with a painting by John McLaughlin.

1959–63

Walks with mother and sister into paradise oasis,

figure 21
Reed House, designed by John August Reed in 1956, San Diego

Taquitz Canyon, Palm Springs, and, after visiting the aquarium, along the beach to tide pools north of Scripps Institution of Oceanography, La Jolla. Wanders through tunnels and bunkers of Battery Ashburn on Point Loma during Boy Scout camp outs.

1961–63
Becomes interested in Kafka, Dada, Duchamp, Artaud, and the Theater of the Absurd.
Sees paintings by John McLaughlin and other abstract paintings at the La Jolla Art Center (now Museum of Contemporary Art, San Diego). Browses through copies of *It Is* and other magazines and catalogues at John Cole's Bookstore next to the museum.

1963
Graduates from Point Loma High School.
Amazed by John Cage's silent laughter after a performance of his music in the Sherwood Auditorium, La Jolla Art Center.
Talks with Marcel Duchamp while viewing his retrospective at the Pasadena Museum: Duchamp says that he "misses painting" and his advice is to continue painting.

1964–68
At Reed College, Portland, Oregon, studies with and sponsored by Willard Midgette.
Organizes Anti-Art Festival.
Starves self for three weeks to act *The Hunger Artist*

in a play based on Kafka's story.
Thrown out of class at the Portland Museum School for refusing to draw in the accepted illustrational style.

1964
Summer life-drawing class with Richard Allen Morris, painter laureate of San Diego, and painting class with Paul Taberski at the La Jolla Art Center. After class, locked in museum at night by mistake.

1965
Summer travel to England and France; most interested in Cézanne. With Paul Auster, hitchhikes to Pamplona and travels to Aix-en-Provence to see landscape Cézanne painted.
Studio class for one month in Venice; impressed by Giotto's frescoes in the Arena Chapel and Tintoretto's paintings in the Scuola di San Rocco.

1966–67
Awarded Rockefeller Foundation grant for one-year leave from college; chooses to study painting during the summer at the Skowhegan School of Painting and Sculpture, Skowhegan, Maine, and during the winter at the New York Studio School, then in its second year, a breakaway school founded by students. Studies especially with Milton Resnick, who says, "I need to cut off your legs at the knees to remove the sense of gravity in your paintings." When first met Resnick, thought him to be Artaud's ghost.

Arrested for putting up anti-war posters, resulting in a few days in the Tombs.

Astounded by paintings in the Jackson Pollock show at the Museum of Modern Art.

Leaves New York for two months during the winter with friend, Charles Munch, to travel and paint the landscape in New Mexico and Arizona; returns alone in the summers of 1967 and 1968 to paint the landscape in Oljato, near Monument Valley, on the Navajo Reservation. Can't afford to buy Lee's Ranch, Utah (figure 22).

1967

Sees *Cheyenne Autumn* and other westerns at the local chapter house with the Navajos who had acted in the movies.

Visits David Monongye, Hopi Elder, at Hotevilla; counseling for conscientious objector status.

1968

Graduates with the first class of art majors at Reed College.

Marries the painter Judy Rifka.

Moves back to New York, lives on the Lower East Side. Works at the Studio School organizing the library; discusses the Southwest landscape, Piero della Francesca, and spaghetti westerns with Philip Guston. Reworks landscapes started in the Southwest into abstractions based on remembered space and light. Studies the de Kooning show at the Museum of Modern Art.

1969

Son, John, born in Manhattan during a snowstorm.

Buys a small adobe house and moves to Barranco, near Abiqui, New Mexico.

Paints the landscape and abstractions based on sensations of light and space.

Befriended by the monks at the Monastery of Christ in the Desert.

1969–71

Receives fellowship and stipend to move to Roswell, New Mexico, to paint for a year-and-a-half. In a large studio with free supplies and away from the pressures of New York, experiments with first large paintings, some ten feet high. Lives in the artists' compound next door to Willard Midgette, Milton Resnick, and Pat Passlof. Views slides of old master paintings with Midgette and other artists.

1970

First paintings in a commercial gallery: Dave Hickey's A Clean, Well-Lighted Place, Austin, Texas.

1971

Moves to a loft in Tribeca, New York City; meets other artists in the streets, bars, and galleries of Soho and participates in the ongoing conversation about art. Returns twelve times to the Barnett Newman show at the Museum of Modern Art.

figure 22
**Ruin of Lee's Ranch,
Valley of the Gods, Utah**

1972

For next five years: works as registrar for Constructivist collection of McCrory Corporation; paints *Door* and *Brushstroke* paintings, working faster and faster to avoid the "split."
Joint-custody, single father with son every other week.
Shares loft with Sumner Crane of *Mars,* "no-wave" rock group.

1976

First studio visit with Max Protetch, future dealer, who comments on the pop aspects of the paintings.

1977

Struck by the sense of California light in Maya Deren's film *Meshes of the Afternoon.* After leaving the theater, sees the buildings and cars in New York as if they were in California and realizes how the different light affects the environment in both places. In New York, stone buildings reveal a depth behind their density. In California, an impenetrable surface layer blocks any entrance.

1978

Death of Willard Midgette, teacher who was a great supporter and example of how to be serious as a painter.

1977–79

Sees Warhol's *Shadow Paintings* and Blinky Palermo's paintings on metal at Galerie Heiner Friedrich, Soho.

1980

After show of six years' work at The Clocktower, tries to develop paintings in color while keeping what was discovered in black and white. Finishes only four paintings in next two years.

1981

Becomes fascinated by Forrest Bess' paintings and sexual theories after seeing show at the Whitney Museum; reads material on Bess at Archives of American Art; research leads to discovery of new works. Begins teaching foundation drawing and painting classes at the School of Visual Arts; continues until 1987.

1984

Co-curates with Lawrence Luhring show at the Studio School, *"I knew it to be so!" Forrest Bess/Alfred Jensen/ Myron Stout: Theory and the Visionary.*
Takes one hundred rolls of slides of Baroque architecture and painting in Milan, Venice, Rome, and Naples. For days sits under skylights in the "color room" of the Capodimonte Museum, Naples, looking at paintings by Lanfranco, Schedoni and the Carracci.
Attends Bernardo Cavallino show and symposium in Cleveland.
Returns to Monument Valley for the first time in seventeen years, with Paul Auster, to help research his novel.

figure 23 (top)
Case Study House #8 (Eames House and Studio), designed by Charles and Ray Eames in 1945–49, Pacific Palisades, California

figure 24 (bottom)
San Lorenzo, designed by Guarino Guarini in 1668–87, Turin, Italy

figure 25
**San Luigi Gonzaga, designed
by Bernardo Vittone in 1738,
Corteranzo Monferrato, Italy**

1985
Paddle trip down the Colorado River, through the
Grand Canyon.

1986
Marries the sculptor Lillian Ball at a ceremony in the
Palazzo Vecchio in Florence.
To trace influences on the Carracci, travels to see paint-
ings by Barocci in Urbino and by Correggio in Parma;
also searches out all paintings by Beccafumi in Siena.

1987
Son, John, leaves home for college.
Sees *The Searchers* by John Ford and remembers cave
shown in movie. Had explored it while painting near
Monument Valley. At the time the cave seemed strangely
familiar. This experience leads to thinking about how
theories of the Fantastic could be applied to painting.

1988
Teaches at Skowhegan School of Painting and Sculpture,
Skowhegan, Maine. Enjoys working with Guy Goodwin
and Barry Le Va.

1989
Death of Nicholas Wilder, friend, painter, and gallerist
who always had the right advice about art, business, and
social etiquette. Like Midgette, he is sorely missed.
Sister, Pamela, moves to New York.
Feels at home in Cologne after seeing painting *#270*
through the windows of the Kölnischer Kunstverein

installed in Rolf Ricke's "Jubilee" show.
The Case Study Houses at MOCA's Temporary Contem-
porary, Los Angeles (figure 23), renew a childhood
fascination with modernist architecture in California.
Trip to Malta to see how the great Mattia Preti painted
directly on the stone vault of St. John's Co-Cathedral.
Work with Bill Bartman on A.R.T. Press publication.

1990
Begins team teaching with Guy Goodwin and, later,
team teaches with David Row at Cooper Union,
New York.
Visits buildings by favorite architects, Guarino Guarini
(figure 24) and Bernardo Vittone (figure 25), in and
around Turin. Up to "heaven" on the scaffolding to see
Correggio's dome under restoration in San Giovanni
Evangelista with Lillian Ball.

1991
Works on collaborative writing project with David
Carrier, which is published in *Arts Magazine:*
"Tradition, Eclecticism, Self-Consciousness: Baroque
Art and Abstract Painting."
Meets Tony Perkins while trying to buy a *New York
Times* from a coin box on Santa Monica Boulevard,
Los Angeles; had premonition of such a meeting as a
teenager. Watching him on the afternoon matinee,
Green Mansions, California light coming in through the
windows and reflecting off the TV screen, was led to
assume that, in the natural course of life, he would be
around in California.

figure 26 (left)
**Bethlehem Baptist Church,
designed by Rudolf Schindler
in 1944, South Los Angeles**

figure 27 (right)
**Frey House II, designed
by Albert Frey in 1963–64,
Palm Springs**

1992

Thinking about a conversation with Nicholas Wilder
and California light decides to be a "bedroom painter."
For a show at the San Francisco Art Institute, digitally
inserts a painting into Judy's bedroom in Alfred
Hitchcock's *Vertigo*.
Traces Scottie's movements through San Francisco with
Bill Berkson.
Travels with Lydia Dona, Stephen Ellis, and John Zinsser
to a symposium on painting organized by Galerie
nächst St. Stephan, Vienna. Gives a paper on
the Fantastic. Visits the Kunsthistorisches Museum.
First place in the Fall Racing Series, Manhattan Yacht Club.
Begins still unfinished photogravure project with
Greg Burnet.

1993

Son, John, finishes graduate school.
Sitting in the Städelsches Kunstinstitut in Frankfurt,
wonders if any contemporary art could have the
honeyed, apodictic atmosphere of the paintings by
Rogier van der Weyden and Jan van Eyck. Later
that day, sees the *Block Beuys* in Darmstadt and finds
that it is possible.
In Bologna, sees reflections of light connecting viewers
to Ludovico Carracci's *Calling of St. Matthew*.

1994

Visiting artist at Cal Arts, Valencia, for the spring
"earthquake" semester: wonderful students who want
"to rebel" by painting.

Lives near the beach in Venice; looks at houses by
Schindler (figure 26), Neutra, Frank Lloyd Wright, Lloyd
Wright and Lautner; visits Albert Frey in his *Frey
House II* in Palm Springs with Lillian Ball, remembers
seeing house under construction during childhood trips
to Palm Springs (figure 27).
Participates in a colloquium with Peter Halley and Ross
Bleckner organized by Sammlung Goetz, Munich.

1995

Local children in Urbino know pet dog, Luna, mini
Dachshund, by name.
Finally sees paintings by Andrea Lilli, including one
in a 1950s modernist church near the beach in
Numana. And sees Barocci's *Entombment* in Senigallia,
in seventeenth-century chapel with sand on the floor.
Both seem perfect paintings for a beach town
(like San Diego).
Walking under the chandeliers of the Mirror Room
in the Neue Galerie, Graz, wonders why the flashes
of spectral light (color everywhere, but unseen)
are a reminder that a vampire cannot be reflected in
a mirror. Watches over eighty vampire movies and
keeps a journal to trace the origin of this question.

1996

Works on color studies in the Baroque gallery of
The Walters Collection, Baltimore; participates in public
discussion with Gail Feigenbaum, Irving Lavin,
and Frank Stella on the relation between Baroque and
contemporary art.

Participates in symposiums on current abstract painting in Madrid and Barcelona; in Barcelona, on the way to the museum, finds a video store specializing in vampire films.
Sees the Malevich retrospective at the Ludwig Museum, Cologne, with Klaus Merkel and Bernard Frize.

1997
Installs pairs of paintings with Fabian Marcaccio at the Künstlerhaus, Bregenz, Austria.
Public discussion with Arthur Danto at Books and Co., New York, about his new book, *Art After the End of Art, Contemporary Art and the Pale of History.*
Inserts painting into *Crime Story,* a TV show set in Las Vegas, to compare the inserted painting with the same painting physically on a wall in Las Vegas.
Finds that the painting looks lonely on the monitor without the actors.
Visits Heizer's *Double Negative* at sunset with Rolf Ricke; skin is colored magenta from rays of distant sun causing memories of painting sunsets in Oljato; lights explode over the Strip in Las Vegas like visions of light desired when painting in the desert.
Paints away from New York in studio at ASAP, Maine.
With sister, watches dramatic red-orange sunset at ocean cliffs below the Museum of Contemporary Art, San Diego. That night, dreams of struggling to rescue woman kidnapped in museum.

1998
Seeing Lee Lozano's *Wave Paintings* installed in the Wadsworth Atheneum, Hartford, renews interest in "postminimal" painting.
Olivier Assayas' film, *Irma Vep,* confirms theories about relations between vampires, technology, painting, and film.
Receives letters from Bill Wilson, many thirty to one hundred pages long, investigating relations between *Vertigo,* vampires, and painting.
Works on essay describing how Caravaggio's way of seeing in *The Calling of St. Matthew* foretells the invention of photography.
Shows slides of twenty-five contemporary abstract painters for a panel honoring Gerhard Richter at the Wexner Center for the Arts, Columbus, Ohio.
Finds photograph of Ellen Browning Scripps standing in the doorway of her "sun parlor," now the Krichman Family Gallery (figure 29). Always favorite room, one of the last vestiges of domestic architecture remaining in the Museum of Contemporary Art, San Diego (figure 28). Thinking that perhaps she is woman kidnapped in dream, tries to conjure her ghost to answer questions about how to plan San Diego exhibition, elicit emotions and memories. Scottie transforms Judy into a ghost in *Vertigo.* A vampire is a ghost that appears at sunset. Perhaps Ellen Browning Scripps is the ghost of this exhibition. Frequent sightings.

figure 28
Ghost of Ellen Browning Scripps in the Krichman Family Gallery (formerly the "sun parlor," Scripps House, designed by Irving Gill in 1916), Museum of Contemporary Art, San Diego

figure 29 (opposite)
Ellen Browning Scripps in the doorway of her "sun parlor" at the Scripps House, designed by Irving Gill in 1916 (now Museum of Contemporary Art, San Diego)

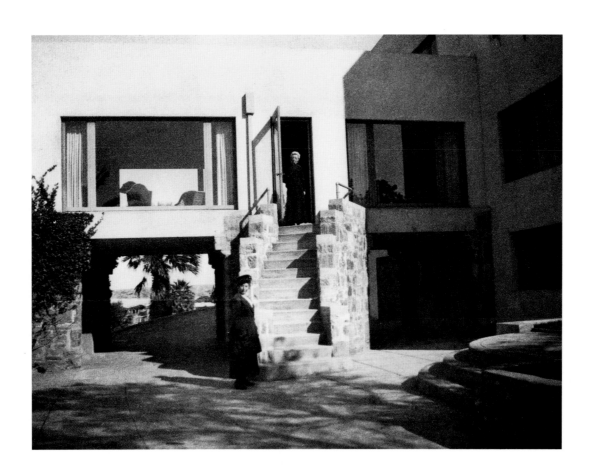

EXHIBITION HISTORY

** indicates catalogue*

David Reed, 1990

1946
- Born in San Diego

Currently
- Lives and works in New York

Education

1968
- Reed College, Portland, Oregon; *Bachelor of Arts* degree

1967
- New York Studio School, New York

1966
- Skowhegan School of Painting and Sculpture, Skowhegan, Maine

Awards and Grants

1991
- National Endowment for the Arts, *Visual Arts Fellowship*

1988
- John Simon Guggenheim Memorial Foundation, *Fellowship*

1969
- Roswell Museum and Art Center, *Grant*

1966
- Rockefeller Foundation, *Fellowship*

Selected Individual Exhibitions

1998
- Museum of Contemporary Art, San Diego
- Max Protetch Gallery, New York
- Vampire Archive/Research Project, Art Resources Transfer, Inc., New York

1997
- Galerie Rolf Ricke, Cologne
- Galerie Bob van Orsouw, Zurich
- Patricia Faure Gallery, Los Angeles

1996
- Donna Beam Fine Art Gallery, University of Nevada, Las Vegas
- * New Paintings for the Mirror Room and Archive in a Studio off the Courtyard, Neue Galerie am Landesmuseum Joanneum, Graz, Austria
- Baumgartner Galleries, Washington, D.C. (with Philip Akkerman)

1995
- * Kölnischer Kunstverein, Cologne
- Württembergischer Kunstverein, Stuttgart (with Beat Streuli)
- Westfälischer Kunstverein, Münster
- Max Protetch Gallery, New York

1993
- Galerie Rolf Ricke, Cologne

1992
- Max Protetch Gallery, New York
- * Walter/McBean Gallery, San Francisco Art Institute, San Francisco

1991
- Galerie Rolf Ricke, Cologne
- Max Protetch Gallery, New York

1989
- Max Protetch Gallery, New York

1988
- Asher/Faure Gallery, Los Angeles
- Max Protetch Gallery, New York

1986
- Max Protetch Gallery, New York

1985
- Max Protetch Gallery, New York

1983
- Max Protetch Gallery, New York

1982
- Grayson Gallery, Chicago

1980
- Institute for Art and Urban Resources/The Clocktower, New York
- Painting Residency, Fashion Moda, Bronx, New York

1979
- Max Protetch Gallery, New York

1977
- Nancy Lurie Gallery, Chicago
- Max Protetch Gallery, New York
- Protetch-McIntosh Gallery, Washington, D.C.

1976
- Rush Rhees Gallery, University of Rochester, New York

1975
- Susan Caldwell Gallery, New York
- Faculty Office Building Gallery, Reed College, Portland, Oregon

Selected Group Exhibitions

1998
- * *Geistes Gegenwart* Diözesanmuseum, Freising, Germany (curated by Petra Giloy-Hirtz and Peter B. Steiner)

- *Pop Abstraction* Museum of American Art of the Pennsylvania Academy of the Fine Arts, Philadelphia (curated by Sid Sachs)

- *I'm Still In Love With You: Visual Artists and Writers Respond to the 1972 Album by Al Green* Women's 20th Century Club, Eagle Rock, California (curated by Steven Hull)

- * *Günter Umberg* Museum Dhondt-Dhaenens, Deurle, Belgium

- *Utz: A Collected Exhibition* Lennon, Weinberg, Inc., New York (curated by Stephanie Theodore)

- *Sick of Photography: A Painting Show* College of Creative Studies Gallery, University of California, Santa Barbara (curated by Michael Darling)

- *Die neue Sammlung (1)* Palais Liechtenstein, Museum Moderner Kunst Stiftung Ludwig, Vienna

- * *Interior Landscapes: An Exhibition from the Collection of Clifford Diver*

Delaware Art Museum, Wilmington

- *From Here to Eternity: Painting in 1998* Max Protetch Gallery, New York (curated by Ruth Kaufmann)

1997
- * *Theories of the Decorative: Abstraction and Ornament in Contemporary Painting* Inverleith House, Royal Botanic Garden, Edinburgh, Scotland; traveled to Edwin A. Ulrich Museum, Wichita State University, Wichita, Kansas (curated by Paul Nesbitt and David Moos)

- *Primarily Paint* Museum of Contemporary Art, San Diego

- *Pintura* Galeria Joan Prats, Barcelona; traveled to Galeria Marta Cervera, Madrid

- * *After the Fall: Aspects of Abstract Painting Since 1970* Snug Harbor Cultural Center, Staten Island, New York (curated by Lilly Wei)

- *Intimate Universe (Revisited): Seventy American Painters* Robert Steele Gallery, New York (curated by Michael Walls)

- *Schilderijen: Reinoud Van Vaught, Fabian Marcaccio, David Reed, Jonathan Lasker*
 Gallerie Tanya Rumpff, Haarlem, the Netherlands

- *Wetterleuchten*
 Galerie Evelyne Canus, La Colle-sur-Loup, France
 (curated by Günter Umberg)

- * *Critiques Of Pure Abstraction*
 Independent Curators, Inc., New York
 (curated by Mark Rosenthal)
 (traveled)

- *Stepping Up*
 Andrew Mummery Gallery, London

- *Relations Between Contemporary Architecture and Painting: Greg Lynn, Fabian Marcaccio, David Reed, Jesse Reiser/ Nanako Umemoto*
 Künstlerhaus Palais Thurn und Taxis, Bregenz, Austria

- *Some Lust*
 Patricia Faure Gallery, Santa Monica, California

- *Installations/Projects*
 Institute for Art and Urban Resources / P. S. 1, New York

1996
- *16 Artists*
 Patricia Faure Gallery, Santa Monica, California

- *Extended Minimal*
 Max Protetch Gallery, New York

- * *Nuevas Abstracciones*
 Museo Nacional Centro de Arte Reina Sofia, Madrid; traveled to Museu d'Art Contemporani de Barcelona; traveled to Kunsthalle Bielefeld, Germany
 (curated by Enrique Juncosa)

- *Abstract Practice*
 Galerie Thaddaeus Ropac, Salzburg, Austria

- *Form als Ziel mündet immer in Formalismus*
 Galerie Rolf Ricke, Cologne

- * *Embedded Metaphor*
 Independent Curators, Inc., New York
 (curated by Nina Felshin)
 (traveled)

- * *Reconditioned Abstraction*
 Forum for Contemporary Art, St. Louis
 (curated by Martin Ball)

- *Lydia Dona and New York Abstraction*

Macdonald Stewart Art Centre, Guelph, Ontario, Canada

1995
- * *Pittura/Immedia: Malerei in der 90er Jahren / Painting in the 90's*
 Neue Galerie am Landesmuseum Joanneum, Graz, Austria
 (curated by Peter Weibel)

- * *Das Abenteuer der Malerei / The Adventure of Painting*
 Württembergischer Kunstverein, Stuttgart and Kunstverein für die Rheinlande und Westfalen, Düsseldorf
 (curated by Martin Hentschel and Raimund Stecker)

- * *Transatlantica, the America-Europa Non-Representativa*
 Museo de Alejandro Otero, Caracas, Venezuela

- * *Abstraction From Two Coasts*
 Lawing Gallery, Houston

- * *Architecture of the Mind: Content in Contemporary Abstract Painting*

 Galerie Barbara Farber, Amsterdam
 (curated by David Moos)

- * *Mesótica: the América non-representativa*
 Museo de Arte y Diseño

Contemporáneo, San José, Costa Rica

- *All About Edges: An Exhibition of Contemporary Abstract Painting*
 Main Gallery, Fine Arts Center Galleries, University of Rhode Island, Kingston
 (curated by Judith Tolnick)

- * *Repicturing Abstraction: The Politics of Space, The Abducted Image, Basic Nature, From Impulse to Image*
 Virginia Museum of Fine Arts, Richmond, Virginia

- *Temporarily Possessed: The Semi-Permanent Collection.*
 The New Museum of Contemporary Art, New York

- * *Going for Baroque: 18 Contemporary Artists Fascinated with the Baroque and Rococco*
 The Contemporary and The Walters Collection, Baltimore
 (curated by Lisa Corrin)

- *"Made In The U.S.A.": Original Paintings on Paper*
 Bob van Orsouw Gallery, Zurich

- * *Re-Fab: Painting Abstracted, Fabricated, and Revised*
 University of South Florida Contemporary Art Museum,

Tampa
(curated by Margaret Miller)

- *Videothek*
 Galerie im Rathaus, Munich
 (curated by Christian Gögger)

1994
- *New Paintings*
 Max Protetch Gallery, New York.

- *Drama*
 Max Protetch Gallery, New York

- * *Chance Choice and Irony*
 Todd Gallery, London; traveled to John Hansard Gallery, University Southhampton, England
 (curated by Colin Crumplin)

- *Recent Painting*
 Asher / Faure Gallery, Los Angeles

- *Conditional Painting*
 Galerie nächst St. Stephan, Vienna

- * *Don't Look Now*
 Thread Waxing Space, New York
 (curated by Joshua Decter)

1993
- * *Fractured Seduction: New Conceptual Abstract Painting, Eight Artists from New York*
 Artifact Gallery, Tel Aviv
 (curated by Maia Damianovic)

- * *Italia-America: L'astrazione ridefinita*
 Galleria Nazionale d'Arte Moderna, San Marino
 (curated by Demetrio Paparoni)

- *Supervision*
 Räume für neue Kunst, Wuppertal, Germany
 (curated by Günter Umberg and Rolf Hengesbach)

- * *Hotel Carlton Palace, Chambre 763*
 Paris
 (curated by Hans-Ulrich Obrist)

- *Bodies of Work*
 Atelier Philip Pocock, Cologne
 (curated by Philip Pocock)

- * *New York Painters: Donald Baechler, Ross Bleckner, Peter Halley, Jonathan Lasker, Richard Prince, David Reed, Peter Schuyff, Philip Taaffe, Christopher Wool*
 Sammlung Goetz, Munich

- *Eight Painters: Abstraction in the Nineties*
 Carl Solway Gallery, Cincinnati

- *Byron Kim, David Lasry, David Reed: Paintings*
 Quint Gallery, La Jolla, California

- *Panorama*
Galerie Martina Detterer,
Frankfurt; traveled to
Galerie Jousse-Seguin, Paris

- *New American Abstraction:*
The Conscious Gesture
Marion Locks Gallery,
Philadelphia

- *New Moderns*
Baumgartner Galleries,
Washington, D.C.

* *Der zerbrochene Spiegel:*
Positionen zur Malerei / The
Broken Mirror: Approaches to
Painting
Museumsquartier Messepalast
and Kunsthalle Wien, Vienna;
traveled to Deichtorhallen,
Hamburg
(curated by Kasper König and
Hans-Ulrich Obrist)

- *Silent Echoes*
Tennisport Arts, Long Island
City, New York
(curated by Christian Haub)

* *Prospect 93: Eine Internationale*
Ausstellung aktueller Kunst /
Prospect 93: An International
Exhibition of Contemporary Art
Frankfurter Kunstverein
and Schirn Kunsthalle
Frankfurt
(curated by Peter Weiermair)

- *Plötzlich ist eine Zeit hereinge-*
brochen, in der alles möglich
sein sollte (Teil 2)
Kunstverein Ludwigsburg,
Germany
(curated by Udo Kittelmann)

* *"I am the Enunciator."*
Thread Waxing Space, New York
(curated by Christian Leigh)

1992

* *Bedroom Pictures*
Asher / Faure Gallery, Los
Angeles
(curated by Terry R. Myers)

* *Thomas Noskowski /*
David Reed
Baumgartner Galleries,
Washington, D.C.

- *Slow Art: Painting in*
New York Now
Institute for Contemporary Art /
P.S. 1, Long Island City,
New York
(curated by Alanna Heiss)

* *Abstrakte Malerei zwischen*
Analyse und Synthese /
Abstract Painting Between
Analysis and Synthesis
Galerie nächst St. Stephan,
Vienna

* *Kinder! macht Neues!*
Galerie Rolf Ricke, Cologne

1991

* *La Metafisica della Luce /*
John Good Gallery, New York
(curated by Demetrio Paparoni)

* *Conceptual Abstraction*
Sidney Janis Gallery, New York

- *The Lick of the Eye*
Shoshana Wayne Gallery,
Santa Monica, California
(curated by David Pagel)

- *Hybrid Abstraction*
Bennington College Art Gallery,
Bennington, Vermont
(curated by Joshua Decter)

* *Strategies for the Next Painting*
Wolff Gallery, New York; traveled
to Feigen Incorporated, Chicago
(curated by Saul Ostrow)

- *Contemporary Abstract*
Painting: Resnick, Reed,
Laufer, Moore
Muscarelle Museum of Art,
College of William and Mary,
Williamsburg, Virginia
(curated by Molly Sullivan)

1990

* *Token Gestures:*
A Painting Show
Scott Hanson Gallery,
New York
(curated by Collins & Milazzo)

1989

* *1989 Biennial Exhibition*
Whitney Museum of American
Art, New York

- *Non-Representation:*
The Show of the Essay
Anne Plumb Gallery, New York
(curated by Jeremy Gilbert-
Rolfe)

* *Diagrams and Surrogates*
Shea and Becker Gallery,
New York
(curated by Saul Ostrow)

* *Aus meiner Sicht: Eine*
Ausstellung von Rolf Ricke /
Jubilee Exhibition of the
Galerie Rolf Ricke
Kölnischer Kunstverein,
Cologne

- *Collapsing Light*
Laurie Rubin Gallery, New York
(curated by Jonathan Seliger)

- *Postmodern Painters*
John Good Gallery, New York

* *Artists of the 80's:*
Selected Works from the
Maslow Collection
Sordoni Art Gallery, Wilkes
College, Wilkes-Barre,
Pennsylvania

1988

- *A New Generation,*
The 80's: American Painters
and Sculptors
The Metropolitan Museum
of Art, New York

- *Louise Fishman, Joan Mitchell,*
David Reed
Barbara Toll Fine Arts Inc.,
New York
(curated by Marjorie Welish)

* *Collaborations in Monotype*
University Art Museum,
University of California,
Santa Barbara
(curated by Phyllis Plous)
(traveled)

* *Formal*
Dart Gallery, Chicago
(curated by Lance Kinz)

- *Seven American Abstract Artists*
Ruggerio Henis Gallery,
New York
(curated by David Carrier)

1987

- *Monsters: The Phenomena*
of Dispassion
Barbara Toll Fine Arts Inc.,
New York
(curated by Dennis Kardon
and Maria Reidelbach)

- *Interstices*
Laurie Rubin Gallery, New York
(curated by Jonathan Seliger)

- *Meaning*
Four Walls, Hoboken, New
Jersey
(curated by David Humphrey)

* *New Locations*
Wolff Gallery, New York

- *Romantic Science*
One Penn Plaza, New York
(curated by Stephen Westfall)

- *The Four Corners of Abstract*
Painting (From Sincerity
to Sarcasm, from Formalism
to Expressionsim)
White Columns, New York
(curated by Bill Arning)

- *Print/Film*
Bess Cutler Gallery, New York
(curated by Victoria Brown
and Christian Haub)

- *Abstract Painting*
Asher / Faure Gallery, Los Angeles

- *Generations Of Geometry:*
Abstract Painting in America
Since 1930
Whitney Museum of American
Art at Equitable Center, New York
(curated by Cheryl Epstein,
M. Christine Hunnisett,
and Kimmo Sarje)

* **40th Biennial Exhibition of Contemporary American Painting**
The Corcoran Gallery of Art, Washington, D.C.
(curated by Ned Rifkin)

1986
* **Abstraction/Abstraction**
Carnegie Mellon University Art Gallery, Pittsburgh; traveled to Klein Gallery, Chicago
(curated by Elaine A. King)

* **Geometry Now**
Craig Cornelius Gallery, New York
(curated by Ruth Kaufmann)

1985
• **Smart Art: New Work from New York**
Carpenter Center for Visual Arts, Harvard University, Cambridge, Massachusetts
(curated by Joseph Masheck)

• **The Non-Objective World— 1985: A Selection of Abstract Painting and Sculpture**
Kamikaze, New York
(curated by Stephen Westfall)

• **An Invitational**
Condeso/Lawler Gallery, New York
(curated by Tiffany Bell)

• **Abstract/Issues**
Sherry French Gallery, Tibor De Nagy Gallery and Oscarsson Hood Gallery , New York
(curated by Steven Henry Madoff)

• **The Art of the 1970's and 1980's**
Aldrich Museum of Contemporary Art, Ridgefield, Connecticut

1984
• **David Reed / Jackie Ferrara**
Susan Montezinos Gallery, Philadelphia

• **Invitational Painting Exhibition: Part I, Twelve Abstract Painters**
Siegel Contemporary Art, New York
(curated by Michael Walls)

• **Abstract Painting**
Susan Montezinos Gallery, Philadelphia
(curated by Per Jensen)

• **24 x 24 x 24: An Invitational Exhibition**
Ruth Siegel Gallery, New York

• **Currents 6: New Abstraction**
Milwaukee Art Museum, Wisconsin

* **Small Works: New Abstract Painting**
Williams Center for the Arts, Lafayette College, Easton, Pennsylvania and Center for the Arts, Muhlenberg College, Allentown, Pennsylvania
(curated by Tom Hudspeth and Ron Janowich)

1983
* **Language, Drama, Source, and Vision**
The New Museum of Contemporary Art, New York
(curated by Lynn Gumpert, Ned Rifkin, and Marcia Tucker)

* **Contemporary Abstract Painting**
Center for the Arts, Muhlenberg College, Allentown, Pennsylvania
(curated by Tom Hudspeth)

• **Nocturne**
Siegel Contemporary Art, New York
(curated by Michael Walls)

• **Three Painters: Sean Scully, David Reed, Ted Stamm**
Zenith Gallery, Pittsburgh

1982
• **An Exhibition of Abstract Painting**
Art Galaxy, New York
(curated by Craig Fisher)

• **Pair Group: Current and Emerging Styles in Abstract Painting**
Jersey City Museum, New Jersey
(curated by Bill Zimmer)

• **Abstract Painting**
Maryland Institute College of Art, Baltimore

1981
• **Arabia Felix**
Art Galaxy, New York
(curated by Bill Zimmer)

• **Bertha Urdang Gallery, New York**
(curated by Lawrence Luhring)

1980
• **Recent Acquisitions**
La Jolla Museum of Contemporary Art, La Jolla, California

* **Investigations: Probe, Structure, Analysis: Agnes Denes, Lauren Ewing, Vernon Fisher, Stephen Prina, David Reed**
The New Museum of Contemporary Art, New York

1979
* **Ateliers Aujourd'hui: Oeuvres Contemporanies des Collections Nationales/ Accrochage II**
Centre National d'Art et de

Culture Georges Pompidou, Paris

• **Fourteen Painters**
Herbert Lehman College, Bronx, New York

1978
• **Two Decades of Abstraction**
University Galleries, University of South Florida, Tampa

1977
• **Recent Acquisitions**
Centre National d'Art et de Culture Georges Pompidou, Paris

1976
• Max Protetch Gallery, New York

• **Students' Choice**
Yale University School of Art, New Haven, Connecticut

1975
* **Abstraction: Alive and Well**
State University College, Potsdam, New York

* **Fourth Annual Contemporary Reflections 1974–75**
Aldrich Museum of Contemporary Art, Ridgefield, Connecticut

* **1975 Biennial Exhibition**
Whitney Museum of American Art, New York

1974
• **Marilyn Lenkowsky, David Reed, Herbert Schiffrin**
Susan Caldwell Gallery, New York

• **John Elderfield, Max Gimblett, David Reed**
Cunningham-Ward Gallery, New York

• **Seven New York Artists**
Nina Nielsen Gallery, Boston

1973
• Lo Guidice Gallery, New York

1972
* **Six Painters in the '70s: Abstract Painting in New York,**
Ackland Art Center, University of North Carolina at Chapel Hill
(curated by John Minor Wisdom)

1970
• **A Clean Well-Lighted Place**
Austin, Texas

• **A Gift of Time**
Santa Fe Museum of Fine Arts, Santa Fe, New Mexico

SELECTED BIBLIOGRAPHY

Selected Books and Catalogues

1998

Delaware Art Museum. *Interior Landscapes, An Exhibition from the Collection of Clifford Diver.* exh. cat. (Wilmington: Delaware Art Museum).

Diözesanmuseum, Freising, Germany. *Geistes Gegenwart.* exh. cat. (Ostildern-Ruit, Cantz Verlag). (Essays by Petra Gilly-Hirtz and Peter B. Steiner.)

1997

Danto, Arthur C. *After the End of Art: Contemporary Art and the Pale of History.* (Princeton, New Jersey: Princeton University Press).

Inverleith House, Royal Botanic Garden, Edinburgh, Scotland and Edwin A. Ulrich Museum, Wichita State University. *Theories of the Decorative, Abstraction and Ornament in Contemporary Painting.* exh. cat. (Edinburgh, Scotland: Royal Botanic Garden). (Essay by David Moos.)

Snug Harbor Cultural Center. *After the Fall, Aspects of Abstract Painting since 1970.* exh. cat. (Staten Island, New York: Snug Harbor Cultural Center). (Essay by Lilli Wei.)

1996

A.R.T. Press, William S. Bartman Foundation. *Between Artists: Twelve Contemporary American Artists Interview Twelve Contemporary American Artists.* (Los Angeles: A.R.T. Press). (Introduction by Dave Hickey.)

Benjamin, Andrew. *What is Abstraction?.* (London: Academy Editions).

Forum for Contemporary Art. *Reconditioned Abstraction.* exh. cat. (St. Louis, Missouri: Forum for Contemporary Art). (Essay by Martin Ball.)

Independent Curators, Inc. *Embedded Metaphors.* exh. cat. (New York: Independent Curators, Inc.). (Essay by Nina Felshin.)

Kunsthalle Bielefeld. *Abstrakte Malerei Heute.* Exh. cat. (Bielefeld, Germany: Kunsthalle Bielefeld).

Museo Nacional Centro de Arte Reina Sofia. *Noves Abstraccions.* exh. cat. (Barcelona: Museu d'Art Contemporani de Barcelona). (Essays by Arthur C. Danto and Enrique Juncosa.)

Museo Nacional Centro de Arte Reina Sofia. *Nuevas Abstraciones.* exh. cat. (Madrid: Museo Nacional Centro de Arte Reina Sofia). (Essays by Arthur C. Danto and Enrique Juncosa.)

Neue Galerie am Landesmuseum Joanneum. *New Paintings for the Mirror Room and Archive in a Studio off the Courtyard by David Reed.* exh. cat. (Graz, Austria: Neue Galerie am Landesmuseum Joanneum). (Essays by Hanne Loreck, Michael Madore, and Peter Weibel.)

Sandler, Irving. *Art of the Postmodern Era, From the Late 1960's to the Early 1990's.* (New York: Icon Editions).

The Contemporary and The Walters Art Gallery. *Going for Baroque: 18 Contemporary Artists Fascinated with the Baroque and Rococo.* exh. cat. (Baltimore: The Contemporary and The Walters Art Gallery). (Essay by Lisa Corrin.)

1995

Gilbert-Rolfe, Jeremy. *Beyond Piety: Critical Essays on the Visual Arts, 1986–1993.* (Cambridge, England: Cambridge University Press).

Independent Curators, Inc. *Critiques of Pure Abstraction.* exh. cat. (New York: Independent Curators, Inc). (Essay by Mark Rosenthal.)

Kölnischer Kunstverein. *David Reed.* exh. cat. (Cologne: Kölnischer Kunstverein). (Essays by Arthur C. Danto and Hanne Loreck.)

Museo Alejando Otero. *Transatlantica, The America-Europa Non-Representiva.* exh. cat. (Caracas, Venezuela: Museo Alejando Otero). (Essay by Raphael Rubinstein.)

Museo de Arte y Diseño Contemporáneo. "*Mesótica: the américa non-respresentiva.* exh. cat. (San Jose, Costa Rica: Museo de Arte y Diseño Contemporáneo). (Essay by Carlos Basualdo.)

Neue Galerie am Landesmuseum Joanneum. *Pittura / Immedia: Malerei in der 90er Jahren / Painting in the '90's.* exh. cat. (Klagenfurt: Verlag Ritter). (Essays by Peter Weibel and Thomas Dreher.)

Virginia Museum of Fine Arts. *Repicturing Abstraction: The Politics of Space, The Abducted Image, Basic Nature, From Impulse to Image.* exh. cat. (Richmond: Virginia Museum of Fine Arts). (Essay by Arthur C. Danto.)

1994

Artifact Gallery. *Fractured Seduction.* exh. cat. (Tel Aviv: Artifact Gallery). (Essay by Maia Damianovic.)

Carrier, David. *The Aesthete in the City: The Philosophy and Practice of American Abstract Painting in the 1980's.* (University Park: Pennsylvania State University Press).

Sammlung Goetz. *New York Painters: Donald Baechler, Ross Bleckner, Peter Halley, Jonathan Lasker, Richard Prince, David Reed, Peter Schuyff, Philip Taaffe, Christopher Wool.* exh. cat. (Munich: Sammlung Goetz). (Essays by Arthur C. Danto and Dave Hickey.)

Todd Gallery. *Chance, Choice, and Irony.* exh. cat. (London: Todd Gallery). (Essay by Tony Godfrey.)

1993

Frankfurter Kunstverein and Schirn Kunsthalle Frankfurt. *Prospect '93: Eine internationale Ausstellung Aktueller Kunst / Prospect '93: An International Exhibition of Contemporary Art.* (Frankfurt: Frankfurter Kunstverein and Schirn Kunsthalle). (Essay by Peter Weiermair.)

Italia-America: L'astrazione redefinita. exh. cat. (San Marino: Galleria Nazionale d'Arte Moderna and Tema Celeste Editions). (Essay by Demetrio Paparoni.)

Masheck, Joseph. *Modernities, Art-Matters in the Present.* (University Park: Pennsylvania State University Press).

Museumsquartier Messepalast and Kunsthalle Wien. *Der zerbrochene Spiegel: Positionen zur Malerei / The Broken Mirror: Approaches to Painting.* exh. cat. (Vienna: Wiener Festwochen). (Essays by Kasper König and Hans-Ulrich Obrist.)

Obrist, Hans Ulrich, ed. *Hotel Carlton Palace, Chambre 763.* (Paris: Oktagon Verlag).

1992
Asher / Faure Gallery. *Bedroom Pictures.* exh. cat. (Los Angeles: Asher / Faure Gallery). (Essay by Terry R. Meyers.)

Auster, Paul. *The Art of Hunger: Essays, Prefaces, Interviews.* (Los Angeles: Sun & Moon Press).

Baumgartner Galleries. *Thomas Nozkowski / David Reed.* exh. cat. (Washington, D.C.: Baumgartner Galleries). (Essay by Marjorie Welish.)

Galerie nächst St. Stephan. *Abstrakte Malerei zwischen Analyse und Synthese / Abstract Painting between Analysis and Synthesis.* exh. cat. (Vienna: Galerie nächst St. Stephan). (Essay by Noemi Smolik.)

Galerie Rolf Ricke. *Kinder! macht Neues!* exh. cat. (Cologne: Galerie Rolf Ricke).

San Francisco Art Institute. *Two Bedrooms in San Francisco.* exh. cat. (San Francisco: San Francisco Art Institute). (Poem by Carlos Basualdo.)

1991
Bann, Stephen and William Allen, eds. *Interpreting Contemporary Art.* (London: Reaktion Books). (Essay by David Carrier.)

John Good Gallery. *La Metafisica della Luce.* exh. cat. (New York: John Good Gallery). (Essay by Demetrio Paparoni.)

Wheeler, Daniel. *Art Since Mid-Century, 1945 to the Present.* (New York: Vendome Press).

Wolff Gallery. *Strategies for the Next Painting.* exh. cat. (New York: Wolff Gallery). (Essay by Saul Ostrow.)

1990
Bartman, William S., ed. *David Reed.* (Los Angeles: A.R.T. Press / William S. Bartman Foundation). (Essay by Charles Hagen.)

Scott Hanson Gallery. *Token Gestures: A Painting Show.* exh. cat. (New York: Scott Hanson Gallery). (Essay by Tricia Collins and Richard Milazzo.)

1989
Kölnischer Kunstverein. *Rolf Ricke: Jubilee Exhibition of the Galerie Rolf Ricke.* exh. cat. (Cologne: Verlag de Buchhandlung Walter König.)

Shea and Becker Gallery. *Diagrams and Surrogates.* exh. cat. (New York: Shea and Becker Gallery). (Essay by Saul Ostrow.)

1988
Dart Gallery. *Formal.* exh. cat. (Chicago: Dart Gallery). (Essay by Joseph Masheck.)

1987
Arnason, H.H. *History of Modern Art: Painting, Sculpture, Architecture, Photography.* Revised and updated by David Wheeler. (New York: Harry N. Abrams).

The Corcoran Gallery of Art. *40th Biennial Exhibition of Contemporary American Painting.* exh. cat. (Washington, D.C.: The Corcoran Gallery of Art). (Essay by Ned Rifkin.)

1986
Carnegie Mellon University Art Gallery. *Abstraction / Abstraction.* exh. cat. (Pittsburgh: Carnegie Mellon University). (Essays by David Carrier and Elaine A. King.)

Craig Cornelius Gallery. *Geometry Now.* exh. cat. (New York: Craig Cornelius Gallery). (Essay by Ruth Kaufmann.)

1984
Masheck, Joseph, ed. *Smart Art.* (New York: Willis, Locker, and Owens).

1980
The New Museum of Contemporary Art. *Investigations: Probe, Structure, Analysis: Agnes Denes, Lauren Ewing, Vernon Fisher, Stephen Prina, David Reed.* exh. cat. (New York: The New Museum of Contemporary Art). (Essays by Lynn Gumpert and Alan Schwartzman.)

Selected Reviews and Articles
1998
Schjeldahl, Peter. "Ultraloungerie: Painting from Another Planet: New Painting from Los Angeles, Deitch Projects; David Reed, Max Protetch Gallery." *The Village Voice* (June 23): 54.

1997
Hickey, Dave. "Top Ten x 12: The Year in Review." *Artforum* 36, no. 4 (December): 89.

Huemer, Markus. "Las Vegas in Cinemascope, Bilder und Videoinstallationen von David Reed in Köln." *Neue Bildende Kunst* (April): 100.

Iannaccone, C. "David Reed at Patricia Faure Gallery." *LA Weekly* (March 14–20): 64.

Imdahl, Georg. "Durch das kalte Feuer des Barock, der maler David Reed zeigt Hitchcock-Paraphrasen und Bilder aus Las Vegas in einer Kölner Galerie." *Frankfurter Allgemeine Zeitung* (July 16): 34.

Joyce, Julie. "David Reed at Patricia Faure Gallery." *Art Issues,* no. 48 (Summer): 41.

Kandel, Susan. "David Reed, Patricia Faure Gallery." *Los Angeles Times* (February 28): F1, F24.

Pagel, David. "David Reed, Patricia Faure Gallery." *art/text*, no. 58 (August–October): 85–86.

Rubinstein, Meyer Raphael. "Abstraction Out of Bounds." *Art in America* 85, no. 11 (November): 104–115.

1996

Buergel, Roger M. "David Reed; der Film als Bild." *Neue Bildende Kunst* (April / May): 52–53.

Danto, Arthur C. "David Reed and Manhattan Baroque." *art press*, no. 218 (November): 55–60.

Kesenne, Joannes. "Abstractie als Hedendaags Realisme." *Kunst & Cultuur* (May): 6.

Neumaier, Otto. "David Reed, Kunstvereinen in Köln, Stuttgart und Münster." *Noema, Art Journal* (Winter): 73.

1995

Allen, Stan. "Painting and Architecture: Conditional Abstractions." *Abstraction. Journal of Philosophy and the Visual Arts* (no. 5): 60–71.

Blase, Christoph. "Köln: Ein Blick mit David Reed ins Schlafzimmer im Kölnischen Kunstverein." *Kunst-Bulletin*, no. 3 (March): 39–40.

Drolet, Owen. "David Reed, Max Protetch Gallery." *Flash Art* 28, no. 183 (summer): 129.

Ermen, Reinhard. "David Reed, Kunstvereinen in Köln, Stuttgart und Münster." *Kunstforum International*, no. 130 (May–July): 376–77.

Madore, Michael. "60 Fractions of Megohm." *Trans>*, Premiere Issue (November): 147–151.

Melrod, George. "Seducing the Eye, Contemporary Painters and Sculptors Turn to Sensuous Abstractions that Revel in Contradictions." *Art & Antiques* (March): 31.

Nemeczek, Alfred. "Köln: David Reed, per Bild bei Hitchcock zu Besuch." *art—das Kunstmagazin* (February): 80–81.

Pocock, Philip. "David Reed—'Bedroom Paintings'/'Vertigo' Kölnischer Kunstverein." *Texte zur Kunst* (May): 175–77.

Schroeder, Annette. "Bild für Bett gewunscht." *Kölnische Rundschau* (January 26).

von Taschitzky, Thomas. "Spiele mit Hitchcock's 'Vertigo' Kölns Kunstverein zeigt den Amerikaner David Reed erstmals in Europa: Bilder und eine Installation." *Kolner Stadt-Anzeiger* (January 26): 11.

Wei, Lilly. "David Reed at Max Protetch Gallery." *Art in America* 83, no. 6 (June): 102.

Ziolkowski, Thad. "David Reed, Max Protetch Gallery." *Artforum* 33, no. 9 (May): 99.

1994

Rosenthal, Mark. "Critiques of Pure Abstraction, David Reed." *Atelier, Magazine of International Art* (October): 78 and cover.

1993

Pincus, Robert. "Byron Kim, David Lasery and David Reed: Paintings." *The San Diego Union-Tribune* (November 18): 17.

1992

Bonetti, David. "Abstract, But Full of Substance, 'Bedroom Painter' at Home with Gestural Extravagance." *San Francisco Examiner*, (August 11): B1, B3.

Cameron, Dan. "(critical edge): The Outlaw Academy." *Art & Auction* 14, no. 10 (May): 96–98.

Gorsen, Peter. "Im Totentanz der Stile, die Chancen abstrakter Malerei / Kunstadebatte in Wein." *Frankfurter Allgemeine Zeitung, Donnerstag* (March 5): Nr. 55 / Seite 31.

Moser, Ulli. "Abstrakte Malerei zwischen Analyse und Synthese, Galerie nächst St. Stephan." *Kunstforum International* (May / June): 370–72.

Murphy, Mary. "Consciousness in the Abstract, A New Look at Abstract Painting." *New Art Examiner* 19 (June / Summer): 16–20.

Nesweda, Peter. "Abstraktion Heute." *Noema, Art Journal* (April–June): 106–107.

1991

Brenson, Michael. "David Reed: Max Protetch Gallery." *New York Times* (March 15): C26.

Decter, Joshua. "David Reed, Max Protetch Gallery." *Arts Magazine* 65, no. 9 (May): 103–104.

Gilbert-Rolfe, Jeremy. "Painting Movement: The Work of David Reed." *Arts Magazine* 66, no. 1 (September): 36–37.

Morgan, Robert C. "David Reed, Max Protetch Gallery." *Tema Celeste* (May–June): 89.

Rubinstein, Meyer Raphael. "David Reed at Max Protetch Gallery." *Art in America* 79, no. 7 (July): 116–17.

Smolik, Noemi. "David Reed: Galerie Rolf Ricke." *Kunstforum International* (July–August): 360–61.

1990

Bell, Tiffany. "David Reed: Max Protetch Gallery." *ArtNews* 89, no. 1 (January): 166–67.

Danto, Arthur C. "The State of the Art World: The Nineties Begin." *The Nation* (July 9): 65–68.

Fisher, Craig. "David Reed at Max Protetch Gallery." *Tema Celeste* (January–March): 64.

Hagen, Charles. "The Anatomy of Autonomy: David Reed." *Artforum* 29, no. 3 (November): 143–46.

Mahoney, Robert. "David Reed, Max Protetch Gallery." *Arts Magazine* 64, no. 5 (January): 102.

Perl, Jed. "The Legend Business." *The New Criterion* 8 (January): 60–62.

Welish, Marjorie. "Body's Surplus: The Art of David Reed." *Sulfur* (Fall): 115–122.

Yau, John. "David Reed, Max Protetch Gallery." *Artforum* 28, no. 5 (January): 8–9.

1989

Danto, Arthur C. "The 1989 Whitney Biennial." *The Nation* (June 5): 778–92.

Donohue, Marlena. "David Reed, Asher/Faure Gallery." *Los Angeles Times* (December 9): 17–18.

Kimmelman, Michael. "New From David Reed, A Modern Traditionalist." *The New York Times* (October 27): C31.

Rubin, Jane. "David Reed at Asher/Faure Gallery." *Art issues,* no. 3 (April): 28.

1988

Gardner, Colin. "Reed moves toward Formal Periphery, His strategy is in the brushstroke." *Los Angeles Herald Examiner* (December 9): 4.

Gilbert-Rolfe, Jeremy. "Nonrepresentation in 1988: Meaning-Production Beyond the Scope of the Pious." *Arts Magazine* 62, no. 9 (May): 30–39.

Grimes, Nancy. "David Reed, Max Protetch Gallery." *The New Art Examiner* 15 (June): 50.

Hagen, Charles. "David Reed, Max Protetch Gallery." *Artforum* 26, no. 8 (April): 147.

Kimmelman, Michael. "David Reed: Max Protetch Gallery." *New York Times* (February 5): C24.

Masheck, Joseph. "Abstract Ironies." *The New Leader* (October 20): 21–22.

Rubinstein, Meyer Raphael and Daniel Wiener. "David Reed: Max Protetch Gallery." *Flash Art,* no. 140 (May–June): 103.

1987

Bell, Tiffany. "Baroque Expansions." *Art in America* 75, no. 2 (February): 126–29, 161.

Seliger, Jonathan. "Interstices: David Reed, Jonathan Lasker, Barry Bridgewood, and Will Mentor." *Arts Magazine* 61, no. 7 (March): 66–69.

1986

Carrier, David. "Artifice and Artificiality: David Reed's Recent Paintings." *Arts Magazine* 60, no. 5 (January): 30–33, cover.

Madoff, Steven Henry. "The Return of Abstraction." ArtNews 85. no. 1 (January): 80–85.

Smith, Roberta. "David Reed: Max Protetch Gallery." *The New York Times* (October 24): C30.

1985

Brenson, Michael. "David Reed: Max Protetch Gallery." *The New York Times* (April 5): C21.

1984

Bell, Tiffany. "David Reed, Max Protetch Gallery." *Arts Magazine* 58, no. 6 (February): 5.

Westfall, Stephen. "David Reed at Protetch Gallery." *Art in America* 72, no. 3 (March): 164.

1983

Brenson, Michael. "David Reed: Max Protetch Gallery." *The New York Times* (November 25): C19.

1982

Tatransky, Val. "An Exhibition of Abstract Painting, Art Galaxy." *Arts Magazine* 57, no. 1 (September): 39.

1980

Foster, Hal. "David Reed, The Clocktower." *Artforum* 19, no. 4 (December): 72–73.

Frank, Elizabeth. "David Reed at the Clocktower." *Art in America* 68, no. 9 (November): 136–37.

Sherry, James. "David Reed's Paintings." *Artforum* 16, no. 5 (January): 54–55.

Zimmer, William. "Artbreakers: New York's Emerging Artists." *Soho Weekly News* (September 17): 41.

1979

Zimmer, William. "Art Goes to Rock World on Fire: The Pounding of a New Wave." *Soho Weekly News* (September 27): 33.

Zimmer, William. "David Reed at Max Protetch Gallery." *Soho Weekly News* (April 26): 41.

1977

Gold, Sharon. "David Reed, Max Protetch Gallery." *Artforum* 15, no. 10 (Summer): 70.

Zimmer, William. "The Younger Generation: A Cross Section." *Art in America* 65, no. 5 (September–October): 86–91.

Zimmer, William. "David Reed at Max Protetch Gallery." *Soho Weekly News* (March 17): 24.

1975

Gruen, John. "David Reed at Susan Caldwell Gallery." *Soho Weekly News* (March 27): 14.

Schjeldahl, Peter. "David Reed at Susan Caldwell Gallery." *Art in America* 63, no. 4 (July–August): 100–101.

Zimmer, William. "David Reed, Susan Caldwell Gallery." *Arts Magazine* 49, no. 10 (June): 8–9.

1974

Frank, Elizabeth. "Marilyn Lenkowsky, David Reed, Herbert Schiffrin, Susan Caldwell Gallery." *Art News* 73, no. 8 (October): 116–20.

Frank, Peter. "John Elderfield, Max Gimblett, David Reed at Cunningham-Ward Gallery." *Soho Weekly News* (March 21): 14, 21.

Gilbert-Rolfe, Jeremy. "David Reed, Susan Caldwell Gallery." *Artforum* 12, no. 10 (June): 70.

1973

Bowling, Frank. "A Modest Proposal." *Arts Magazine* 47, no. 4 (February 1): 55–59.

Selected Artist's Writings, Statements, and Interviews
1998

"Scottie's Place / Judy's Place." *Carnal Pleasures: Desire, Public Space and Contemporary Art.* Ed. Anna Novakov. Clamor Editions, San Francisco.

1997

"Journal." *New Paintings for the Mirror Room and Archive in a Studio off the Courtyard.* Neue Galerie am Landesmuseum Joanneum. Graz, Austria.

1996

"David Reed." *Fotografie nach der Fotografie / Photography after Photography.* Verlag der Kunst, Berlin. 301. (letter)

"David Reed." *Peindre? Enquête & Entretiens sur la Peinture Abstraite.* Eds. Claude Briand-Picard, Christophe Cuzin, Antoine Perrot. Positions, Galerie b Jordan m Devarrieux, Paris. 112. (statement)

"David Reed: Vampire Journal Excerpt." *New Observations, Ripple Effects: Painting and Language, #113.* (Winter): 6–7.

Ellis, Stephen. *Between Artists: Twelve Contemporary American Artists Interview Twelve Contemporary American Artists.* A.R.T. Press, William S. Bartman Foundation, Los Angeles. 183–94. (interview)

Smolik, Noemi. "David Reed: Eigentlich ist es die abstrakte Malerei, die heute die Errungenschaften der Pop-art fortsetzt und weiterentwickelt." *Kunstforum* 133 (February–April): 300–305. (interview)

1995

"David Reed." *Pittura / Immedia, Malerei in den 90er Jahren / Painting in the '90's.* Neue Galerie am Landesmuseum Joanneum, Graz. 120–21. (statement)

Krebber, Sabine. "Hitchcock's Schlaftzimmer." *Stuttgarter Nachrichten* (July 7): Kultur Magazin 13. (interview)

"Two Bedrooms in San Francisco." *David Reed.* Kölnischer Kunstverein, Cologne.

von Taschitzki, Thomas. "Bilder vom Bruch im Selbst." *Kölner Stadt-Anzeiger* (March 12): 39. (interview)

1994

"David Reed." *Fractured Seduction.* Artifact Gallery, Tel Aviv. (statement)

1993

"Media Baptisms." *M/E/A/N/I/N/G* #13 (May): 31–33.

"David Reed." *Der zebrochene Spiegel: Positionen zur Malerei / The Broken Mirror: Approaches to Painting.* Museumsquartier Messepalast und Kunsthalle Wien, Vienna. 118–21. (statement)

"David Reed." *Prospect '93: Eine Internationale Ausstellung aktueller Kunst / Prospect '93: An International Exhibition of Contemporary Art.* Frankfurter Kunstverein and Schirn Kunsthalle Frankfurt, Germany. 355. (statement)

Paparoni, Demetrio. *Italia-America: L'astrazione redefinita.* Galleria Nazionale d'Arte Moderna, San Marino. 129–33. (interview)

1992

"Media Baptisms." *Abstrakte Malerei zwischen Analyse und Synthese / Abstract Painting between Analysis and Synthesis.* Galerie nächst St. Stephan, Vienna. 123–34.

"Two Bedrooms in San Francisco." *Two Bedrooms in San Francisco.* San Francisco Art Institute.

1991

"Reflected Light: In Siena with Beccafumi." *Arts Magazine* (March): 52–53.

"Tradition, Eclecticism, Self-Consciousness: Baroque Art and Abstract Painting." *Arts Magazine* (January): 44–49. (with David Carrier)

1990

Ellis, Stephen. *David Reed.* A.R.T. Press, William S. Bartman Foundation, Los Angeles. (interview)

1989

"Memories of Rome." *New Observations* #68 (June): 20–23.

1988

Rubinstein, Raphael. *ETC. Magazine,* Montreal, Canada (Summer): 31–33. (interview)

Seliger, Jonathan. *Journal of Contemporary Art* (Spring): 67–8. (interview)

1984

"I Knew It to Be So!" *I Knew It to Be So!—Forest Bess, Alfred Jensen, Myron Stout, Theory and the Visionary.* New York Studio School.

1975

"On Jumping." and "Intermediate Cases." *Art-Rite* (Spring): 9.

Public Collections

AT&T, Basking Ridge, New Jersey
Centre National d'Art et de Culture Georges Pompidou, Paris
Chase Manhattan Bank, New York
Cincinnati Art Museum, Cincinnati, Ohio
Corcoran Gallery of Art, Washington, D.C.
General Mills, Minneapolis, Minnesota
Hirshhorn Museum and Sculpture Garden, Smithsonian Institution,
 Washington, D.C.
Louisiana Museum of Modern Art, Humlebaek, Denmark
Museum Moderner Kunst Stiftung Ludwig, Vienna, Austria
Museum of Contemporary Art, San Diego
The Metropolitan Museum of Art, New York
Reed College, Portland, Oregon
Roswell Museum and Art Center, Roswell, New Mexico
Sammlung Goetz, Munich
Tel Aviv Museum, Tel Aviv, Israel
Weatherspoon Art Gallery, University of North Carolina
 at Greensboro

LENDERS TO THE EXHIBITION

Mrs. Albert L. Anderson, San Diego
Harry W. and Mary Margaret Anderson
Ingrid Calame, Los Angeles
Irina Alimanestianu-Chao, Venice, California
Linda and Ronald F. Daitz, New York
Mr. and Mrs. Herb Edelberg, New Jersey
Patricia Faure Gallery, Santa Monica, California
Pauline and Stanley Foster, Rancho Santa Fe, California
Sammlung Goetz, Munich
Dr. Carl Grover
Eloisa and Chris Haudenschild, La Jolla, California
Christa and Wolfgang Häusler, Munich
Steven Hull, Los Angeles
Diane and Steven Jacobson, New York
Barbara and Howard Morse
Museum of Contemporary Art, San Diego
Private collection, Bad Homburg, v.d.H., Germany
Private collection, Cologne
Private collection, New York
Alisa Tager and David Pagel, Los Angeles
Monique Prieto and Michael Webster, Los Angeles
Max Protetch Gallery, New York
Beverly and David Reed, San Diego
David Reed, New York
John Reed, New York
Galerie Rolf Ricke, Cologne
Irwin and Beth Robbins, Gladwyn, Pennsylvania
Robert Shapiro, San Diego
Marjorie and Charles Van Dercook, New York
Robin and Fred Warren, Los Angeles
Linda Yeaney, Los Angeles

PHOTO CREDITS

Boris Becker, Cologne: p. 14
Collection La Jolla Historical Society: p. 85
Dennis Cowley, New York: cover, pp. 1–4, 13, 36, 38–49, 56–58
 (artworks), 60–71 (artworks)
Bevan Davies, New York: pp. 8, 10, 52–55 (artworks)
James Dee, New York: p. 23
Andrea Geyer, New York: pp. 60–67 (video frame stills), 84
Wolfgang Günzel, Offenbach, Germany: p. 59 (artwork)
Lisa Kahane, New York: pp. 21, 52–55 (views of exhibition)
Johann Koinegg, Graz: p. 19
David Reed, New York: pp. 79–82
David F. Reed II, San Diego: p. 76
John August Reed, Los Angeles: pp. 56–59 (architecture)
Pamela Reed: p. 86
Courtesy Ed Ruscha: p. 22
Courtesy Sonnabend Gallery, New York: p. 26
Squidds & Nunns: p. 28
Vampire Archive/Art Resource, New York: pp. 68–71
 (background images)
Michael Varon, New York: p. 25